POSTCARD HISTORY SERIES

Redondo Beach

1880–1930

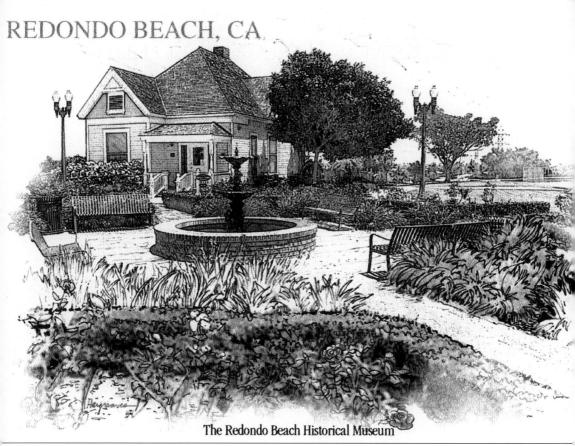

The Redondo Beach Historical Museum

HISTORICAL MUSEUM. The Redondo Beach Historical Museum is located at 302 Flagler Lane and is open to the public for research, tours, and browsing. Proceeds from the sale of this historic postcard book will benefit the museum. (Courtesy of Collector Classics by Hargreaves.)

POSTCARD HISTORY SERIES

Redondo Beach

1880–1930

Historical Commission of Redondo Beach

ARCADIA

Published by Arcadia Publishing
Charleston SC, Chicago IL, Portsmouth NH, San Francisco CA

Printed in Great Britain

Library of Congress Catalog Card Number: 2005936616

For all general information contact Arcadia Publishing at:
Telephone 843-853-2070
Fax 843-853-0044
E-mail sales@arcadiapublishing.com
For customer service and orders:
Toll-Free 1-888-313-2665

Visit us on the Internet at www.arcadiapublishing.com

CONTENTS

ACKNOWLEDGMENTS

Redondo Beach is an official project of the Redondo Beach Historical Commission, approved by the city council.

Patricia Allen Dreizler, chairman and project editor
Mary Ann Keating, past chairman and project writer
Anne Hughes, vice chairman and postcard archivist
Barbara Roamer, secretary and postcard historian
Bradley Reynolds, member and postcard archivist
John Reilly, member and postcard archivist

The Redondo Beach Historical Museum collection

City of Redondo Beach Department of Recreation and Community Services: Paula Matusa, historical commission liaison; Constantine Karavas, historical museum clerk.

Technical Advisers: Linda Aust, Byron Jost, Dr. Karl Swearingen.

Postcard Publishers: The Benham Indian Trading Company, Cardinell and Vincent Company, S. B. Clemm, H. S. Crocker Company, Garden City Photo, M. Kasthower Company, Newman Post Card Company, George O. Restall, Souvenir Publishing Company, M. Rieder Publishing, Western Publishing and Novelty.

Special Thanks to Jeff Abbey, A. R. "Red" Allison, Terri Aylward, Patricia Botsai, Carl Cameron, Sandra Ceman, Lou Garcia, Tom Gaian, Arlis Gordon, Carmen Hernandez, F. S. "Bill" Haynes, Maggie Healy, Greg Hill, The Horrell Family, Janet Johnson, H. Smith Keating, Carolyn Lininger, Lillian Lunt, Shirley McDonald, John McGehee, Charlotte Price, Robert Ramsay, Irene Sagahon, Senior Clubs, Marna Smeltzer, Gloria Snyder, Phil Serpico, JoAnn Turk, Art Wible, and Jianulla Zimmerman.

INTRODUCTION

"Drop Me a Card"
1880–1930

Buy 'em for a nickel, mail 'em for a penny. That was part of the allure of picture postcards, which, by the early 20th century, were all the rage in Redondo Beach, as eastern tourists wanted to let friends and relatives know that there really was a California coast.

Catering to this tourist trade, early Redondo Beach postcards showcased the port's fishing possibilities. They pictured the 250-room Hotel Redondo and life along the shore, with its moonstone beach and sheer cliffs.

Postcards in various forms had popped up all over the world since the mid-1800s, but the first copyright in this country for a private card was issued to Philadelphia printer John P. Charlton in 1861 and transferred to his friend and fellow printer, H. L. Lipman, who produced cards decorated with a border pattern and labeled "Lipman's postcard card, patent applied for."
The idea spread, and in 1873, U.S. government postals were issued—plain cards with room on one side for the address and space on the other for a simple message.

By 1889, cards in Europe showed the Eiffel Tower and England's Parliament Building as well as museum treasures. The Inter-State Industrial Exposition of 1873 in Chicago was the first to feature an exposition, while Chicago's Columbian Exposition in 1893 was the first card printed especially to be used as a souvenir. Those early postcards could be mailed for 2¢ until 1898, when American publishers were allowed to print and sell cards with the inscription "Private Mailing Card, Authorized by Act of Congress on May 19, 1898." On that date, the mailing rate dropped to a penny, where it stayed until after World War II.

Publishers were permitted to drop the private mailing card notice in 1901, but writing in the United States was still limited to the front with only the address on the back until March 1, 1907, when the rules changed. The address moved to the right side, while the left side could contain written messages, leaving the front for pictures.

Information supplied by the American Numismatic Society shows that today, coin and stamp collecting are the two most popular hobbies worldwide, while deltiology (the formal name for postcard collecting) is the third-largest hobby in the world, probably because of the broad appeal of subjects, from whether scenic views, to cityscapes, to bathing beauties. And just as it was 100 years ago, today when friends go on vacation, they're always cajoled to "drop us a postcard."

This book of early postcards is intended to spark an interest in the period from 1880 to 1930. The book hints at time frames and is meant to tweak curiosity with its brief snippets. The Historical Commission of Redondo Beach hopes that curious readers will use the bibliography to enrich their own knowledge of the city of Redondo Beach.

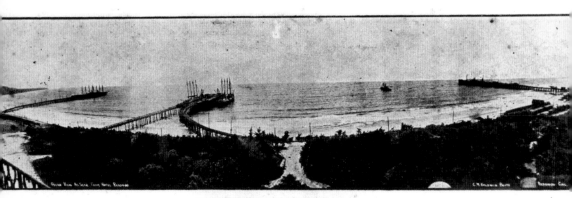

REDONDO BAY AND WHARVES

VIEW FROM HOTEL REDONDO. All three wharfs were busy with passenger ships and freighters from the 1890s to the 1920s. Perhaps it was this view that inspired the official Redondo Beach song, "Redondo by the Sea." Written by Margaret Gorman with music by Charles J. Morey, it was published in 1907 by the Redondo Improvement Company. The last lines read, "When far away by heart shall stay, at Redondo by the sea."

One

BEFORE THE BEGINNING

The first inhabitants of Redondo Beach were the Chowigna Indians, California coastal natives who took advantage of the climate, the abundant harvest from the ocean, and the salt from a lake near where the border of Hermosa Beach is today. The Chowigna were a lodge of the Gabrielano tribe. Modern history dates to when Juan Rodriguez Cabrillo discovered the sweeping Santa Monica Bay in 1542. However, the area remained mostly undeveloped until the late 1880s, when Congress appropriated money for the harbor in San Pedro and lumber began arriving from the Pacific Northwest.

In 1887, the Redondo Company bought 1,400 acres from the heirs of Juan Dominguez, including the land from what today is bordered by Knob Hill on the south to Herondo on the north and from Prospect on the east to the ocean. William Hammond Hall, the state engineer who designed Golden Gate Park, was brought from San Francisco to lay out the city, taking advantage of the round shape and amphitheater-like topography. In the original land grant, the 22,458-acre area adjacent to Rancho San Pedro was referred to as Rancho Sausal Redondo, translated as "round willow grove."

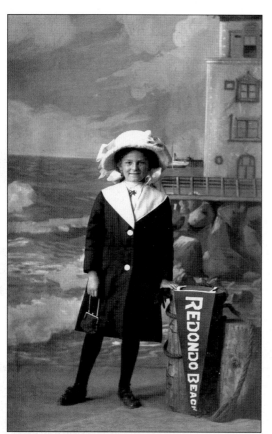

RAH FOR REDONDO. Making a postcard souvenir of her visit to Redondo Beach, this smartly dressed young lady could tell her Ohio friends how she bought the pennant at the beach for just a few pennies.

LEMON'S STUDIO. When postcards gained in popularity across the country, people wanted their own picture in front of whatever attraction they were visiting. Lemon's studios popped up in small towns and large, with the Redondo Beach location always a stop for eastern visitors.

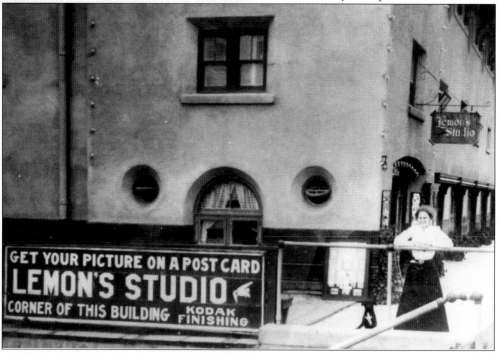

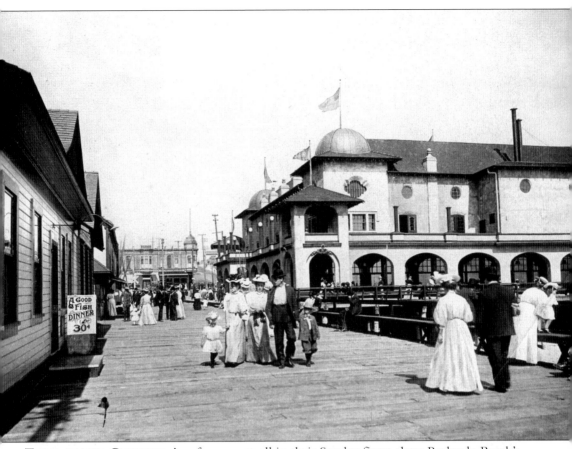

Turn of the Century. An afternoon stroll in their Sunday finest along Redondo Beach's busy waterfront attractions was popular with those who wanted to enjoy a 30¢ fish dinner or a peek into the Mandarin Ballroom in the pavilion, pictured at right. This view looks east toward Emerald Street.

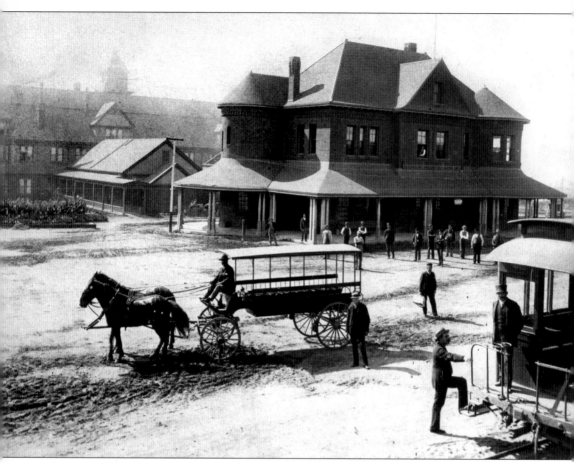

REDONDO RAILWAY STATION. The Santa Fe line brought tourists from the east to this early station. A promotion by the railroad once offered tickets for $1 from Kansas City, Missouri, to Redondo Beach. Here a station wagon driver waits with his horses for passengers from the arriving train. A 1908 diary kept by a young man from Wichita, Kansas, comments on the excitement he and his parents felt when their train pulled into the station. The trip to California was his high-school graduation gift.

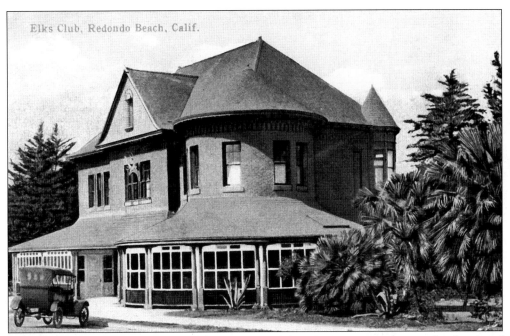

Elks Club, Redondo Beach, Calif.

OLD ELKS CLUB. Today's Redondo Beach Elks Club near Veterans Park occupies the site of the early Elks Club, which was converted from the train station.

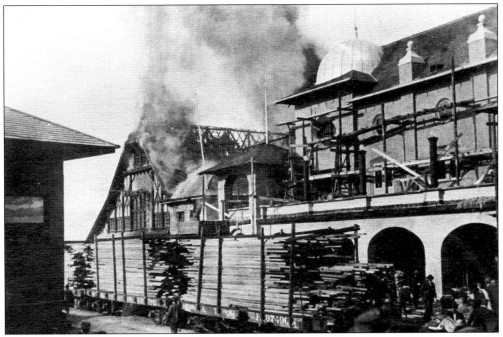

FIRE BEHIND THE CASINO RESTAURANT. A restaurant of unique Bavarian architecture, the Casino was under construction alongside the pavilion around 1890. These two buildings were major landmarks along the waterfront during the early 20th century.

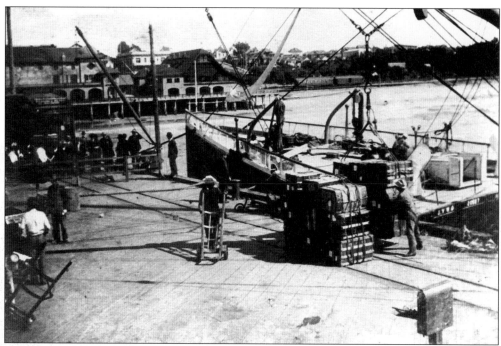

UNLOADING CARGO. During the early 1900s, the Redondo Beach pier was a busy place for cargo ships. The amusement area in the background was the site of the popular Tent City, where, for $1 a night, people could rent a tent with a wooden floor and a single light bulb.

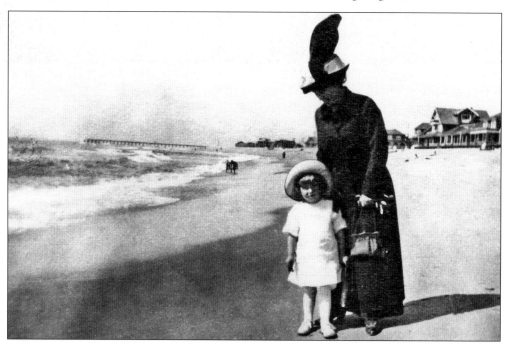

VIEW NORTHWARD. Sophie Dockstader and her daughter Phoebe enjoy the waves lapping at the sandy beach. The houses on the waterfront were large and comfortable. In the background is one of the early piers, probably built to accommodate the burgeoning shipping industry.

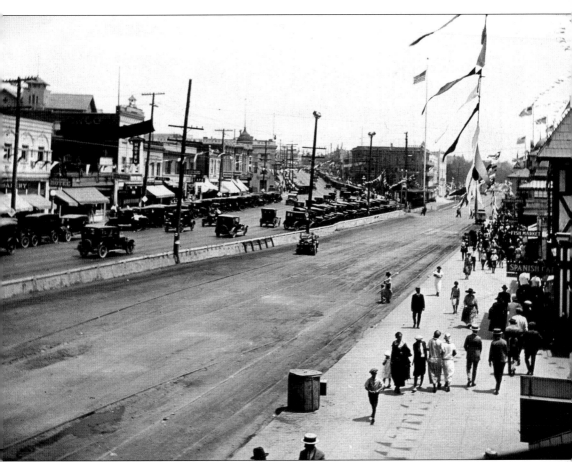

ALONG EL PASEO. Clothing stores, a candy shop, a pharmacy, a frock shop, and a small hotel make up this shopping area to the left. Visitors and shoppers stroll along El Paseo on the right.

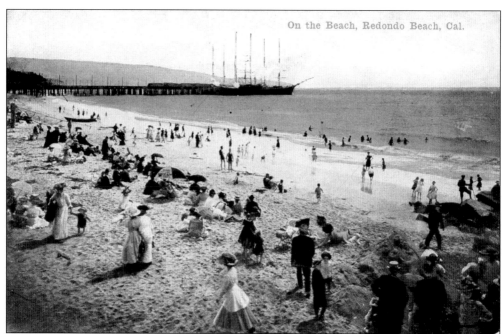

On the Beach, Redondo Beach, Cal.

WHARF NO. 1. The outline of the Palos Verdes Peninsula is in the background of this 1890 view of Wharf No 1. At this time, Redondo Beach was a major port for the Los Angeles area, handling most of the lumber coming in from the Pacific Northwest. Ship arrivals were always occasions for beachgoers to enjoy the sand and waves.

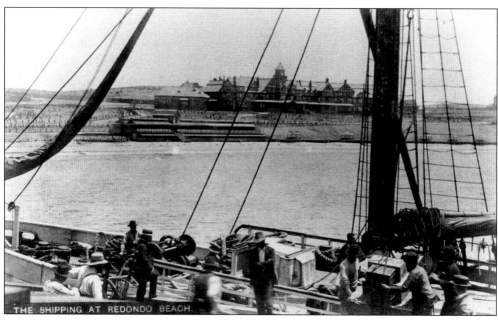

THE SHIPPING AT REDONDO BEACH.

VIEW FROM THE WHARF. From Wharf No. 1 at the base of Emerald Street, this view was typical of the early 1890s. In the background is the Hotel Redondo, located in what is now Veterans Park.

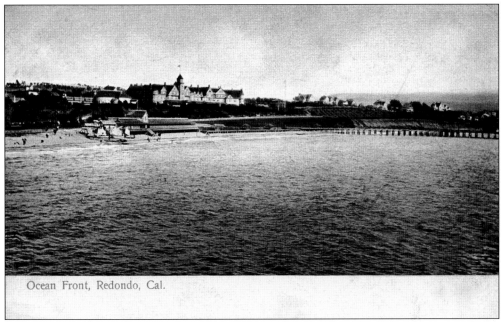

Ocean Front, Redondo, Cal.

BEFORE 1907. This view of the Hotel Redondo is printed on a pre-1907 postcard. The small space at the bottom is for a simple message. After 1907, messages were allowed on the back of the card along with the address.

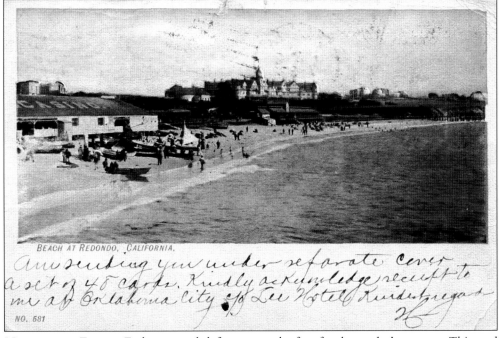

BEACH AT REDONDO, CALIFORNIA.

NO. 581

MESSAGE ON FRONT. Early postcards left space on the face for the sender's message. This card to a friend in Pennsylvania shows the Hotel Redondo with the beach in the foreground. It is postmarked 1908. The original casino is on the left.

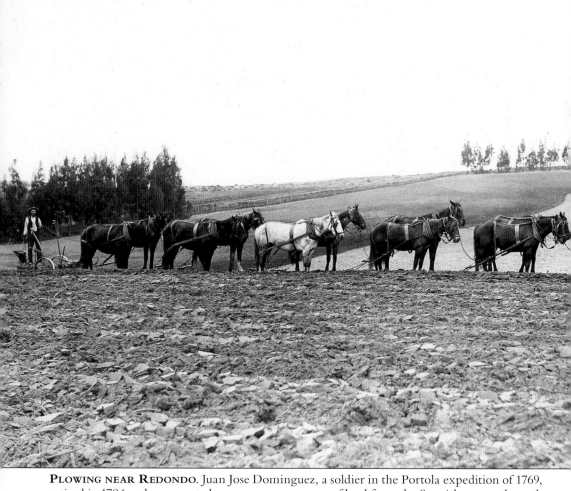

PLOWING NEAR REDONDO. Juan Jose Dominguez, a soldier in the Portola expedition of 1769, retired in 1784 and was granted an enormous expanse of land from the Spanish crown through his commander, Governor Fages. The 75,000-acre Rancho San Pedro Grant included the Palos Verdes Peninsula and the present-day Redondo Beach. Cattle roamed Redondo until farmers began plowing and planting.

Two

AFTER THE BEGINNING
A TOWN EVOLVES

The vote was 177 to 10 on Election Day, April 25, 1892, when local people went to the polls to decide whether or not the Redondo Beach Company's 400 acres along the Pacific Ocean would become a town. With such overwhelming approval, it was no wonder that a mixture of civic pride and investment dollars began fueling an economy that, in the early 21st century, supports a city of some 63,000 residents.

Pride and faith in Redondo Beach have been the backbone of its stability through the years, as its leaders have withstood depressions and war, have lobbied Congress for development dollars, and have lured major aerospace industry to build West Coast headquarters near the beach.

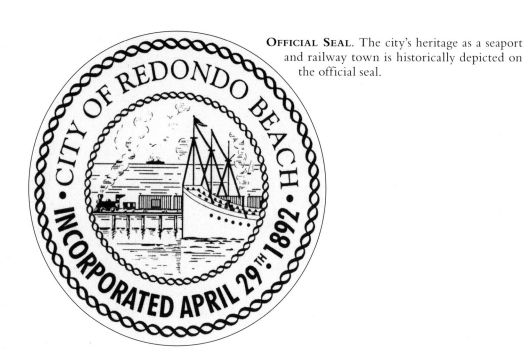

OFFICIAL SEAL. The city's heritage as a seaport and railway town is historically depicted on the official seal.

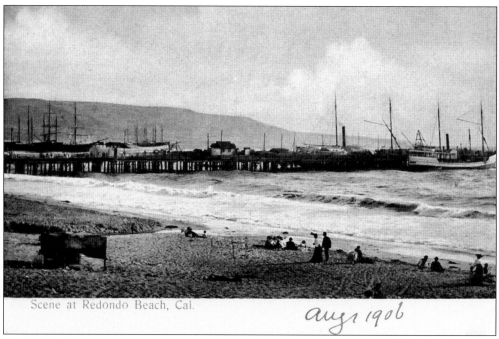

Scene at Redondo Beach, Cal.

aug 1906

BEACH PEOPLE, 1906. Long skirts and bathing attire that never went into the water were the dress of the day in the early 20th century. Tall masts dot the scene at the end of the pier, and the Palos Verdes Peninsula is in the background.

20

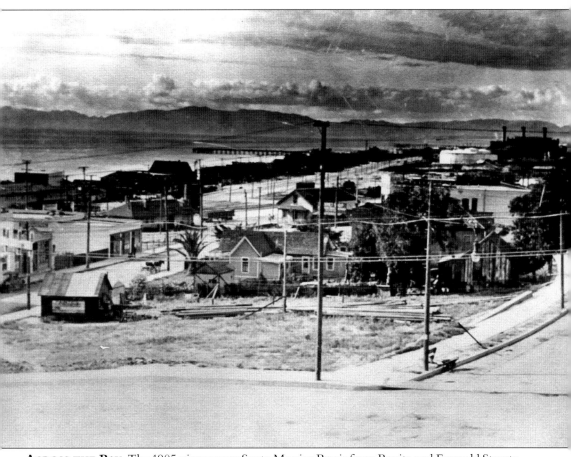

ACROSS THE BAY. The 1905 view across Santa Monica Bay is from Benita and Emerald Streets. It shows the mountains in the background and a lone pier stretching out from the beach. The steam plant is at the upper right.

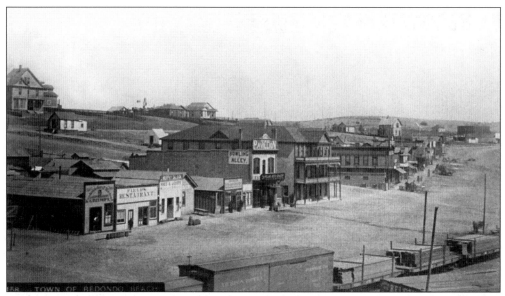

BUSINESS DISTRICT. The flourishing Redondo Beach business district is pictured here from the foot of Emerald Street at the end of the 19th century. Note the bowling alley, Field's Restaurant, and lumber stacked on the waiting flat cars.

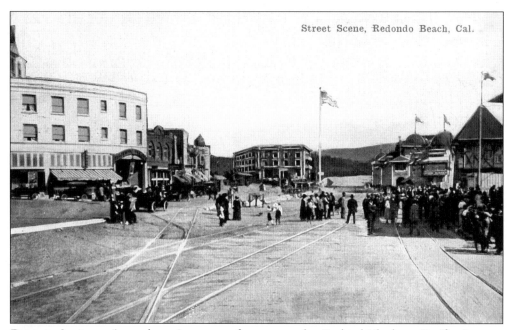

PACIFIC AVENUE. An early main center of town was the Garland Block on Pacific Avenue. When Redondo Beach incorporated in 1892, there were six chartered religious congregations: Methodist Episcopal, St. James Catholic, Christ Episcopal, Presbyterian, Gospel Union Mission, and Congregational.

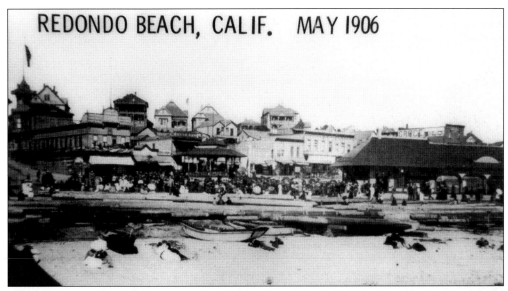

REDONDO BEACH, CALIF. MAY 1906

MAY 1906. A decade after Redondo Beach's founding, the town had elegant homes overlooking an abundance of shops along the shore, bringing reality to the foresight of two river boat captains, J. C. Ainsworth and R. R. Thompson. The two were partners in the Oregon Steamship and Navigation Company. After founding Redondo Beach, they maintained freight and passenger service between Portland, Oregon, and the South Bay. Pictured above left is the original city hall, with its flag flying. The Santa Fe Railroad, pictured on the right, began service in 1888 and was one of three railroads serving the growing town.

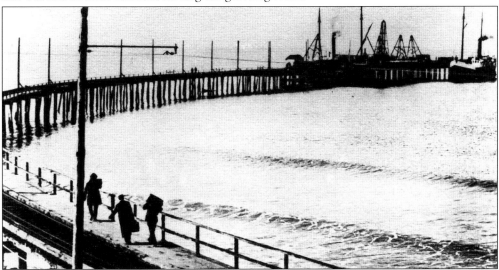

WHARF NO. 2. In 1910, this pier enabled visitors to walk out to the awaiting passenger ships. Before J. C. Ainsworth and R. R. Thompson arrived on the scene, Daniel Freeman of Inglewood and his partner N. R. Vail, along with Judge Charles Silent, bought 400 acres between the salt lake at the northern part of town and an area south of Redondo called Clifton. They paid three daughters of Manuel Dominguez $12,000 for the real estate. Manuel was the nephew of Juan Dominguez, to whom the original land grant was issued. The daughters were Guadalupe, Susana, and Reyes. Unfortunately, the venture went broke. It was up to Captains Ainsworth and Thompson to make Redondo Beach a reality. Rail lines ran out to the end of the pier.

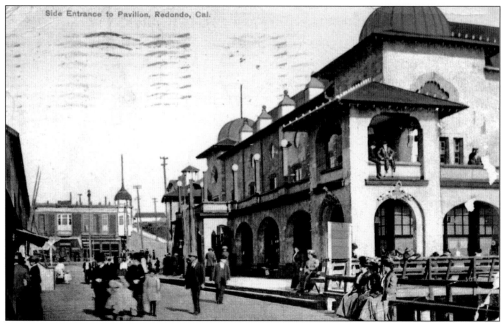

SCENE FROM THE WHARF. This view of the side entrance to the pavilion captured the imagination of a visitor from Anderson, Indiana, who sent the card home to his wife. A message written in October 1908 comments on the "fit of the clothes of the people on the boardwalk."

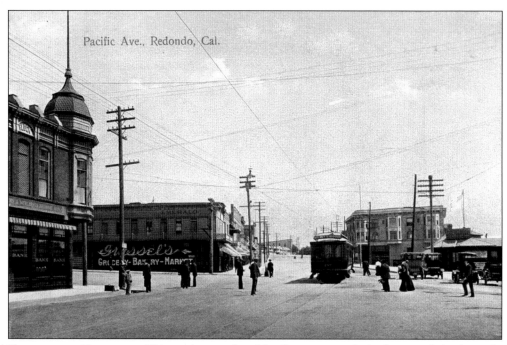

PRINTED IN GERMANY. This card was printed in Germany, typical of postcards in the early 1900s. Note that people are waiting for the Red Car from downtown Los Angeles.

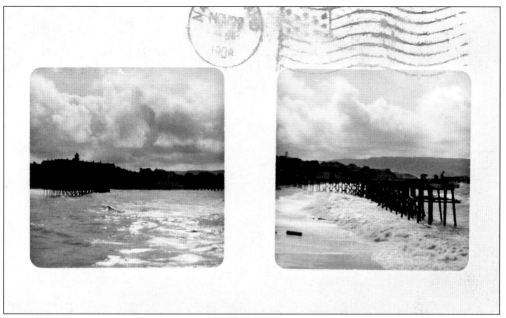

POSTCARD TO IDAHO. Postmarked 1904, this card to a woman in Emmett, Idaho, says, "This is one of the prettiest places I've ever seen." The dual scene features the outline of the Hotel Redondo on the left and the pier with the Palos Verdes Peninsula on the right.

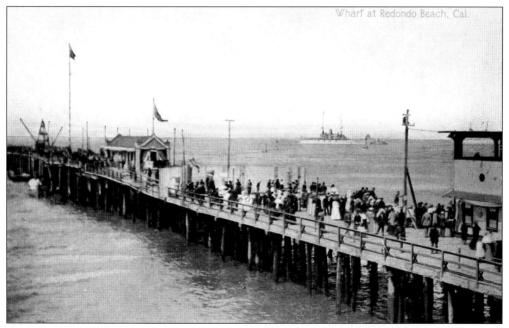

FISHING FROM WHARF NO 1. This 1908 scene shows ships in the background riding high above the water, obviously empty from the lumber cargo just off-loaded nearby. In 1908, William Howard Taft was elected president of the United States and General Motors Corporation was founded.

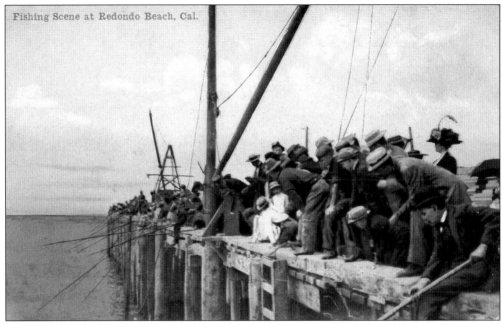

Fishing Scene at Redondo Beach, Cal.

FISHING, 1908. Fishing from the pier in Redondo Beach always has been a favorite pastime. Note that the men are wearing hats and the women are in typical dress, with flowers on their hats and broaches at their necklines.

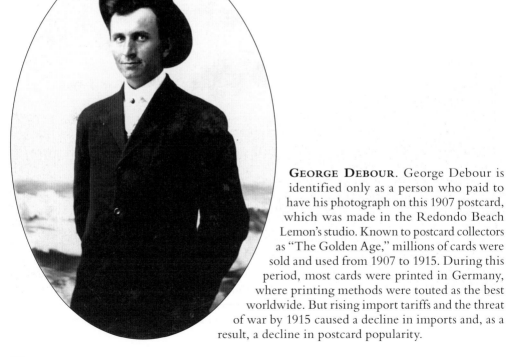

GEORGE DEBOUR. George Debour is identified only as a person who paid to have his photograph on this 1907 postcard, which was made in the Redondo Beach Lemon's studio. Known to postcard collectors as "The Golden Age," millions of cards were sold and used from 1907 to 1915. During this period, most cards were printed in Germany, where printing methods were touted as the best worldwide. But rising import tariffs and the threat of war by 1915 caused a decline in imports and, as a result, a decline in postcard popularity.

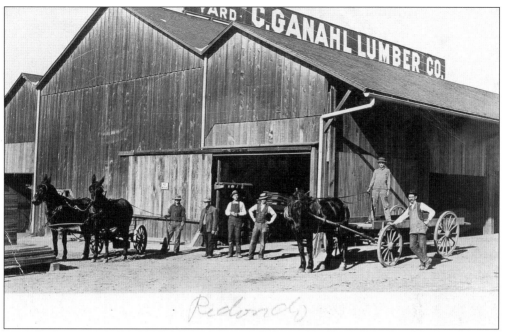

BUSY LUMBER YARD. The C. Ganahl Lumber Company's wagon teams were kept loaded as the lumber industry flourished. Ships laden with building supplies from the Pacific Northwest arrived at Redondo Beach's wharfs almost daily

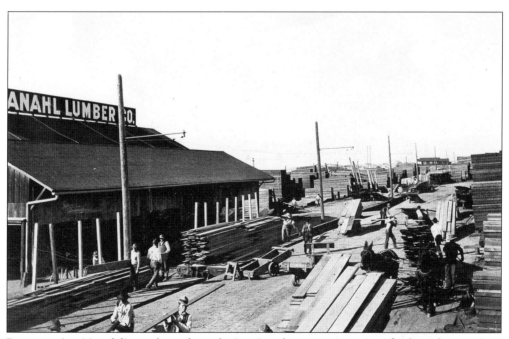

LUMBER. Awaiting delivery throughout the Los Angeles area, mountains of redwood are cut into manageable lengths to fit onto the delivery wagons. Lumber came to Redondo Beach around the horn and from the Pacific Northwest.

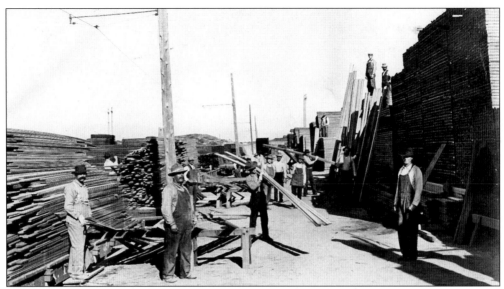

HEAVY INDUSTRY. With more than half of the total virgin lumber in the United States grown in the three Pacific states of Washington, Oregon, and California, people soon realized that the lumber trade could be expected to be a stable business for Redondo Beach. The first lumber company in Redondo Beach was Montgomery and Mullin, where most of the imported lumber was planed.

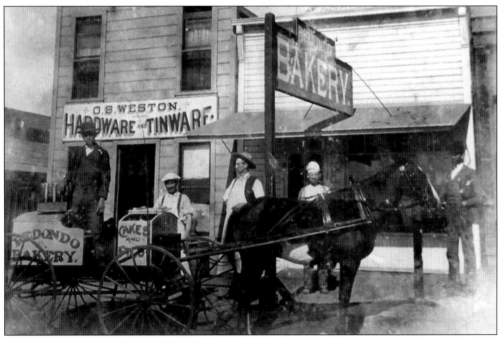

HARDWARE STORE. O. S. Weston's Hardware and Tinware supplied necessary material as the town began to grow in the late 1890s. Next door was the bakery that delivered freshly made bread and cakes by horse-drawn cart.

Three

TRAINS, PLANES, AND BIG RED CARS

No review of Redondo Beach's past would be complete without a look at the Redondo Railway's 17 miles of track to Los Angeles or the Pacific Electric's Red Cars, which cost a quarter for a 50-minute commute to downtown Los Angeles. Adding color to the city's past were the gambling ships just off shore. They were nothing more than barges with roulette wheels, but they had flamboyant advertising and claimed to be beyond the reach of California's police by three miles. In 1938, some 1,500 people each night rode the water taxi from Redondo Beach out to the *Rex*, a 20-minute trip that cost 25¢.

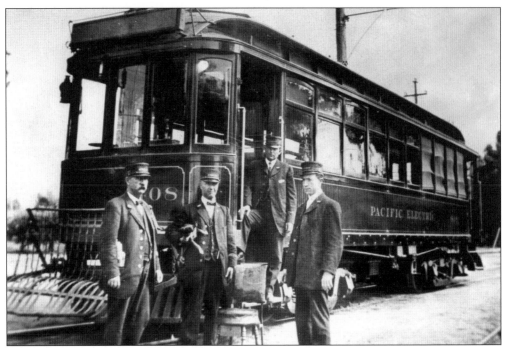

TROLLEY OF THE REDONDO–DEL REY LINE. This car of the Pacific Electric Railway began in downtown Los Angeles, ran out to the beach at Playa del Rey just south of the mouth of Ballona Creek, then southward along the beach through Manhattan Beach, down the middle of Hermosa Avenue in Hermosa Beach, and terminated in Redondo Beach. The scheduled time was 55 minutes from Los Angeles to Redondo Beach. The line was taken out of service in 1940.

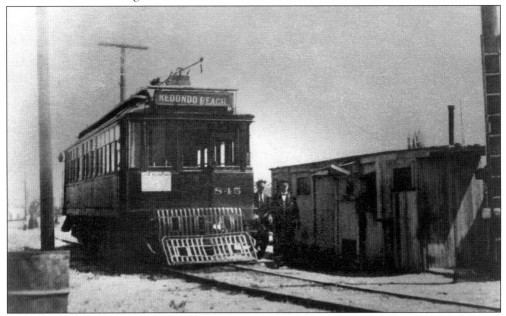

THE STRAWBERRY LINE. One Redondo Beach trolley ran through Gardena, where acres of strawberries flourished. The nickname "Strawberry Line" stuck with those who rode the trolley from Los Angeles to pick fresh berries each spring.

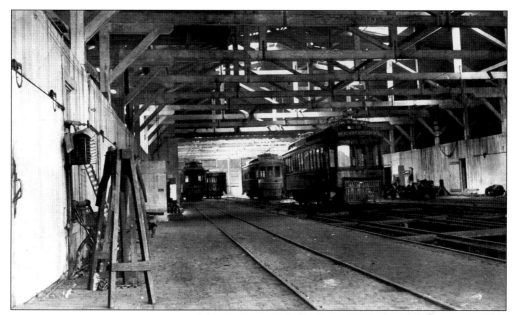

CAR BARN. The Redondo Beach car barn was located behind the Hotel Redondo. Cars were cleaned and maintained, then put out on the route back north. The post office murals by Paul Sample recall the days before the automobile when the South Bay was served by Santa Fe steam passenger trains.

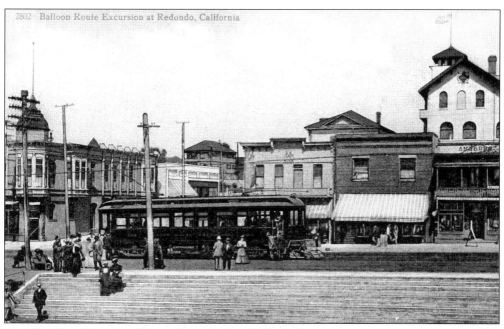

THE BIG RED CAR. It really was big and red, and it brought passengers to the area on a dependable schedule. The Los Angeles & Redondo Railway car was the first interurban trolley to be built in Redondo Beach. The cars ran between Redondo and downtown Los Angeles via Inglewood or Gardena. As many as a thousand people a day enjoyed the ride along with its dependability. The original city hall is pictured at upper right.

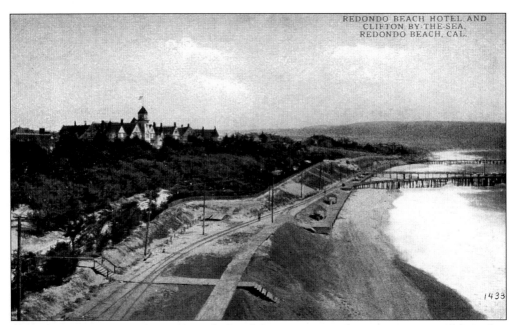

RAILROAD TRACKS. Tracks ran along the beach, going out onto the pier to meet vessels bringing passengers to the Hotel Redondo on the hill. The Pacific Coast Steamship Company's steam lumber schooner *Eureka* was the first to arrive with its redwood to build a pier. Not only did Redondo Beach welcome the lumber for its own growth, but the concurrent development of Los Angeles spawned massive importation, creating a burgeoning industry.

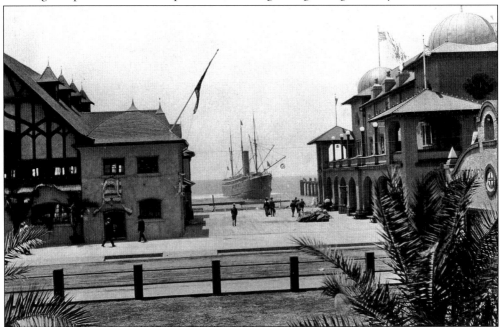

SHIP ARRIVES. By 1889, a recorded 86 vessels had called at Redondo Beach and 8,216 tons of building supplies had been handled. Another 182 vessels landed cargoes in 1890. And in 1891, imports from coastal vessels to Redondo Beach were 20 million feet of lumber and 29,179 tons of other general merchandise. The Santa Fe Station is pictured on the right.

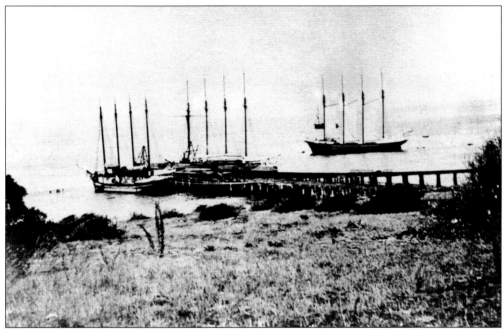

MAIN SEAPORT. Cargo ships docked at Wharf No. 2 at the foot of Pearl Street in 1890. During this period, Redondo Beach was the main seaport for Los Angeles.

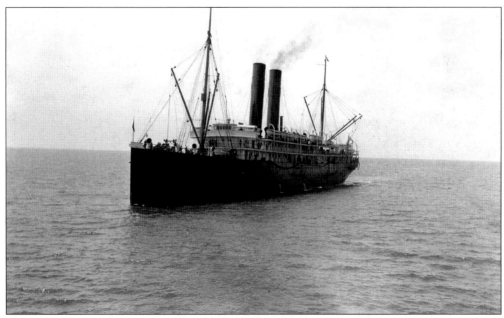

PASSENGER SHIP. By 1896, Redondo Beach saw 35 percent of the area's shipping trade. Passenger ships brought hundreds of visitors in 1904, while the railroad that year carried 110,000 people to the area.

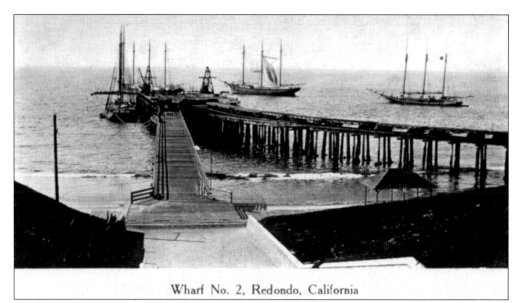

Wharf No. 2, Redondo, California

WHARF NO. 2. Ships line up, waiting for a spot along Wharf No. 2, in this view from the Hotel Redondo. The wharf was demolished in 1916, possibly weakened by the storm of March 1915, which tore into the entire coastal area. As a sub-port of Los Angeles after 1912, Redondo Beach gradually became a cargo shipping nonentity along with the port at Santa Monica. By 1911, ground was broken for the Standard Oil refinery in El Segundo, which effectively ended Redondo's participation in the oil trade. Redondo Beach was left with nothing but a passenger port.

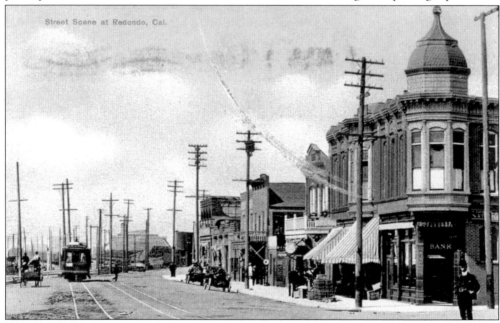

Street Scene at Redondo, Cal.

STREET SCENE, 1910. Cars, trolleys, and utility lines were common in the early development of Redondo Beach. This scene looks north along Pacific Avenue, with Diamond Street nearby. Members of the Dominguez family assisted in naming the streets. Those running north and south were given the names of daughters and family relatives, while those extending from east to west were named after precious stones.

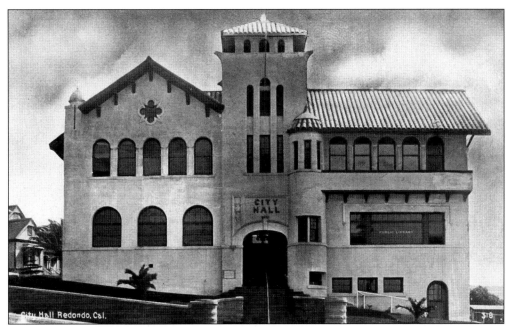

CITY HALL. Early Redondo Beach had a library, a city hall, and a police and fire station all in the same building. The garage for school buses was located behind city hall. By 1910, the town also boasted a Woman's Club and several churches.

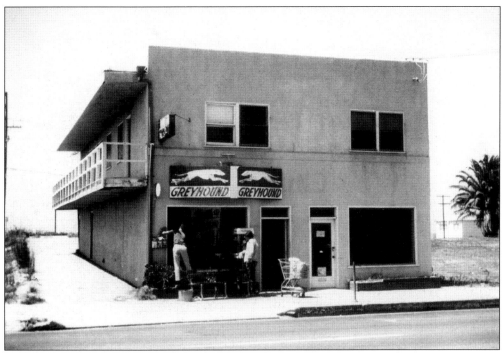

GREYHOUND BUS STATION. Located on Catalina near Garnet, the bus station was one of the earliest along the coast. People came to Redondo Beach for more than just a good time. They came to shop, do business, and consider buying real estate. At one time, there were almost 100 real estate offices promoting Redondo Beach.

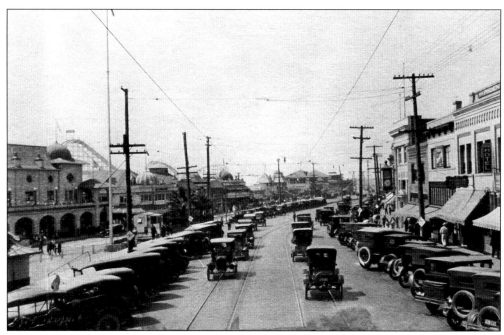

EARLY PARKING PROBLEM. In 1924, not only did people drive to Redondo Beach from other areas, but the town's residents wanted their own models of whatever Henry Ford was putting out that year. This view looks north along Pacific Avenue toward the El Paseo amusement area.

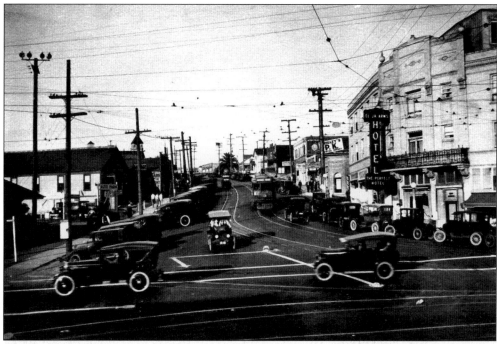

DIAMOND STREET. This view of Diamond Street is from the intersection of Diamond and Pacific Avenue during the early 1920s. The El Ja Arms Hotel, pictured at right, was frequented by film star Charlie Chaplin, one of many Hollywood celebrities who enjoyed the local attractions.

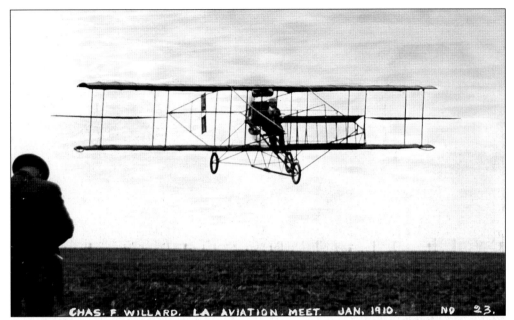

AVIATION MEET. The 1910 Los Angeles Aviation Meet saw planes flying up and down the coast as pilots showed off their skills. Love of aviation grew quickly, and on December 2, 1929, more than 30,000 people attended the first major American glider meet at the Hollywood Riviera field adjacent to Redondo Beach.

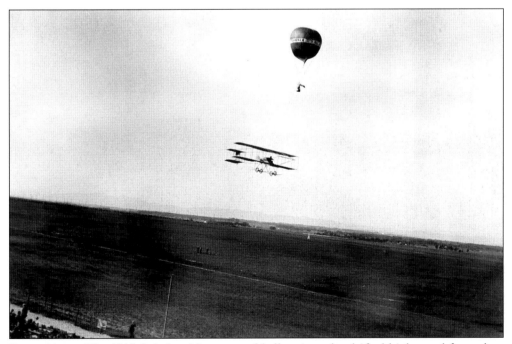

BALLOONIST. The 1910 Aviation Meet sported balloonists who drifted higher and faster than the planes, making use of the currents off the ocean.

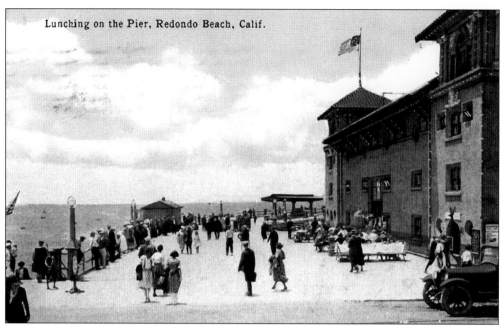

Lunching on the Pier, Redondo Beach, Calif.

LUNCHING ON THE PIER. This 1926 view of the Redondo Beach Pier shows how easily people could drive to the beach. They could catch fish, cook whatever they caught, and eat at the nearby picnic tables. The assessed valuation of the city was in excess of $5 million, and businesses were flourishing.

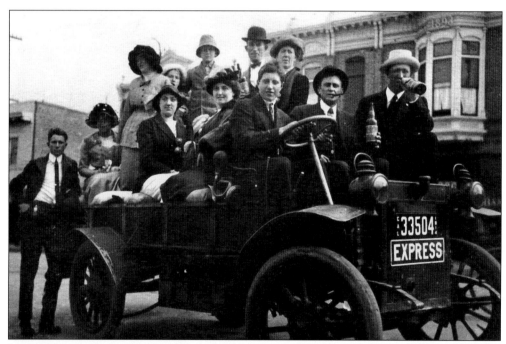

JULY 1914. That's the date on this souvenir postcard. The photograph was taken on Pacific Avenue, just north of Emerald Street. People enjoyed having their personal photos turned into postcards that could be mailed to relatives.

Four

PLACES TO STAY, PLACES TO PLAY

Redondo Beach was a seaside mecca for those who came by rail or steamship to enjoy the resort. Standing on the bluff where Veterans Park is today, Hotel Redondo had 225 rooms and boasted a bathroom on every floor. Built in 1889, every room had sunlight, and the exterior was a mélange of chimneys and spires. An orchestra played at dinner, and the grand ballroom was alive with festivities weekly. Unfortunately, Prohibition killed the hotel's appeal, and in 1926 its remains were sold for scrap.

Even without the hotel, Redondo Beach enjoyed the lure of the water. Built in 1907 by Henry Huntington, a gigantic pavilion covering more than 34,000 square feet was a mere 150 feet from the shoreline near today's pier. Nearby was the Plunge, billed as the "largest indoor salt water heated pool in the world." Many of the attractions were along El Paseo, a street which no longer exists but which evolved to the south as the Esplanade. When the amusements lost their appeal, gambling absorbed the glitter of El Paseo and the street became a magnet for gaming interests.

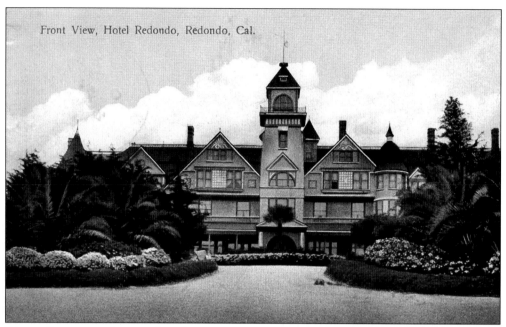

HOTEL REDONDO. Sent to a friend in San Francisco, this card has a 1900 postmark and a message saying that the writer would "take dinner" at the Hotel Redondo. The hotel was built for some $500,000 and opened on May 3, 1890.

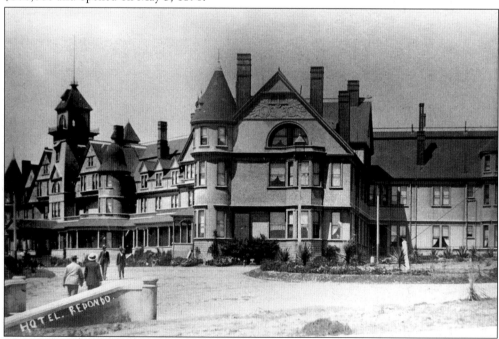

SPRAWLING ARCHITECTURE. Every room at the Hotel Redondo sported a different décor, but the overall look was English, with hunting scenes in the hallways. On Easter Sunday, 1913, a crowd of approximately 12,000 people swarmed to Redondo Beach for the day's festivities. A newspaper account of the day reads, "The ladies of Redondo Beach served a three course luncheon to invited guests and long tables of yellow jonquils and ferns decorated the hotel's tables."

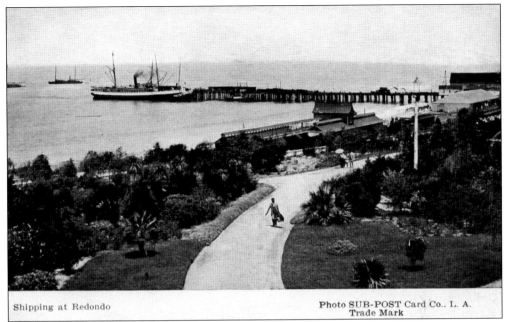

Shipping at Redondo

Photo SUB-POST Card Co., L. A.
Trade Mark

HOTEL REDONDO, 1908. Perched atop a hill in today's Veterans Park, the Hotel Redondo had a commanding view across the beach and on to the horizon, where visitors could watch the ships arrive and depart. A deed restriction regarding hotel operations specified that liquor was not to be sold on the premises. However, liquor was readily available in nearby bars, described by some as "within staggering distance."

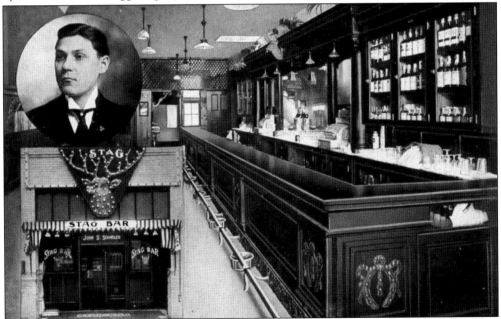

STAG BAR. Even though liquor wasn't sold in Hotel Redondo, patrons didn't have far to stroll for a sip or a draft before Prohibition. One of Redondo Beach's popular post-Prohibition spots was the Stag Bar on Pacific Avenue. Its owner John Schindler sent this postcard to potential patrons advertising the buffet at the bar where "everything is new but the ocean."

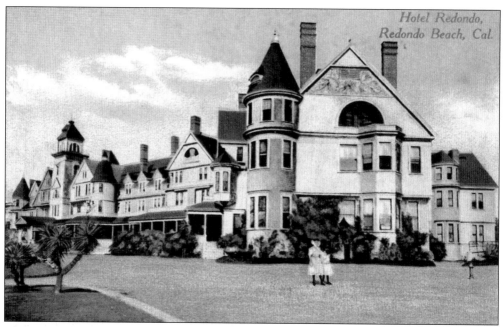

VIEW FROM THE BEACH. The Redondo Railway station was at the back of the Hotel Redondo, but visitors arriving from the coastal steamers approached from the front, glimpsing elegant flower beds.

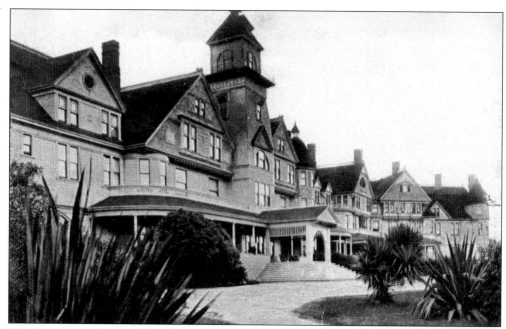

HOTEL IS SOLD. Manager J. S. Woolacott sold the Hotel Redondo on January 1, 1910, to Newton J. Skinner and W. J. Conner, who promised to overhaul and refurbish to the tune of $25,000.

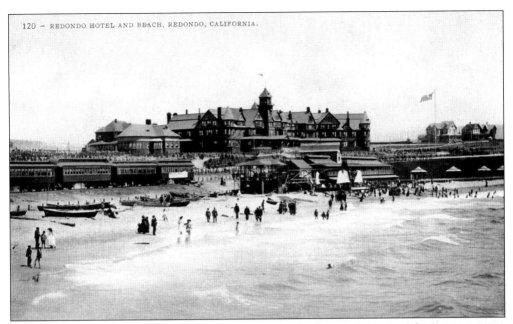

DECEMBER 1912. This card was written to a relative in Sierra Madre, California. It suggests a vacation to see the splendid Hotel Redondo. The year 1912 marked the first time a woman registered to vote in Redondo Beach: 85-year-old Alvira Heath Jenks.

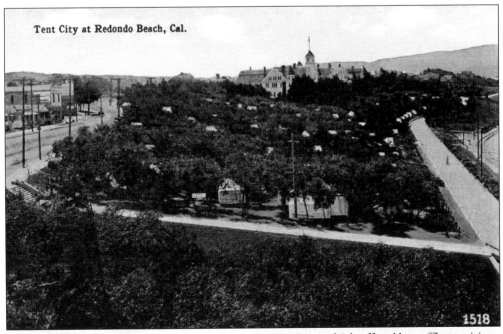

Tent City at Redondo Beach, Cal.

1518

TENT CITY. White dots in the foreground denote Tent City, which offered less-affluent visitors a wooden floor, an electric light and a tent for a seaside vacation, all for the cost of $1. Legend has it that J. C. Ainsworth would never refuse anyone passage to Redondo Beach, even if the passenger had no money. Perhaps it was that altruistic spirit that led this early founder to build the first Tent City near Pacific Avenue and Garnet Street.

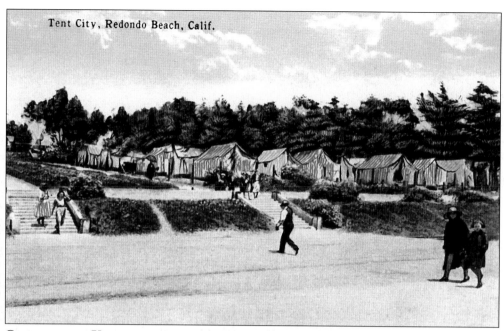

Tent City, Redondo Beach, Calif.

COMFORTABLE VACATION. Visitors enjoyed the fact that Tent City provided beautiful sunset views, easy strolls to the beach, and nearby fishing. A shower tent was also provided.

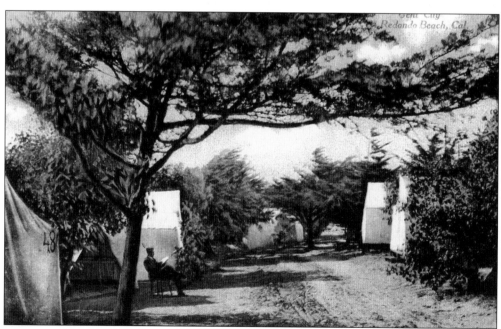

LANDSCAPED FOR BEAUTY. Tent City was a hit not only with those who couldn't afford the Hotel Redondo but also with those who simply enjoyed sitting under the shade trees, watching the shipping in the harbor, and knowing they could have privacy only a few feet away.

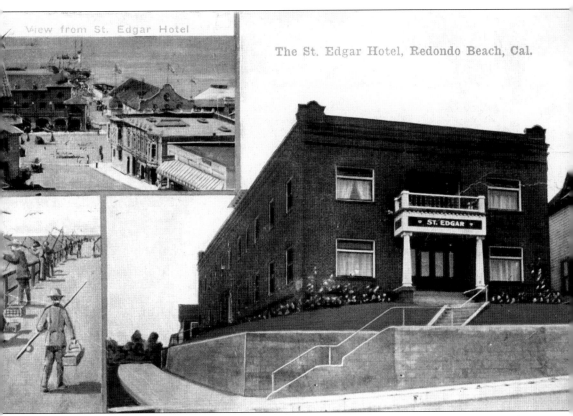

View from St. Edgar Hotel

The St. Edgar Hotel, Redondo Beach, Cal.

ST. EDGAR

FOR CLEAN PEOPLE. Billing itself as new and modern, the St. Edgar Hotel had 50 rooms equipped with hot and cold water, private baths, a roof garden, and a sun parlor. "A clean place for clean people" was its motto. Rooms were $2 a day, and the telephone number was SUNSET-1.

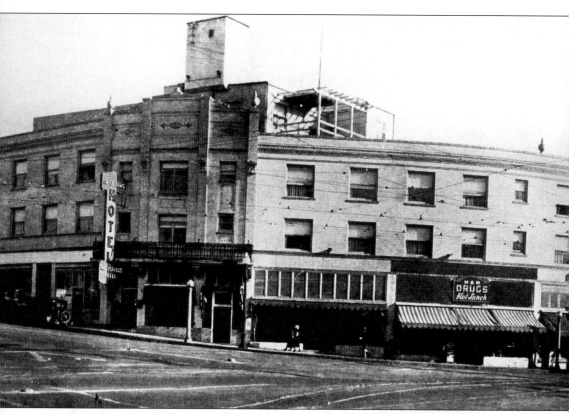

OTHER HOTELS. Early Redondo Beach boasted several hotels. The El Ja Arms was particularly popular with the new Hollywood crowd. It was built by L. J. Bombach, hence the name from his initials. He was a beer distributor and had a girlfriend named Ma Clary, who operated a nearby chowder house. Just down the street at the corner of Emerald and Benita was the Esmeralda Hotel, with a first-class restaurant and what was advertised as "good rates."

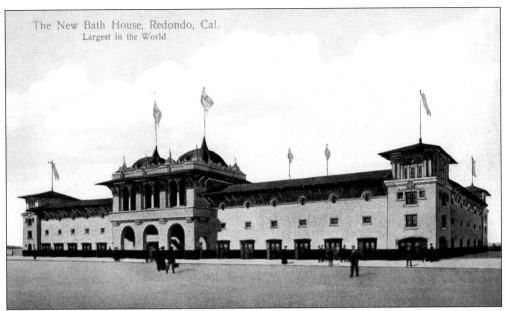

The New Bath House, Redondo, Cal.
Largest in the World

LARGEST IN THE WORLD. This scene proclaimed the arrival of Redondo Beach's new bathhouse, claimed to be the largest in the world. Tourists could swim in the ocean or in the $150,000 bathhouse, which had warm and cold water. The building was 278 feet long by 107 feet wide, with 1,330 dressing rooms and 62 tub baths. Its July 1909 grand opening was billed as "a coronation fit for a king."

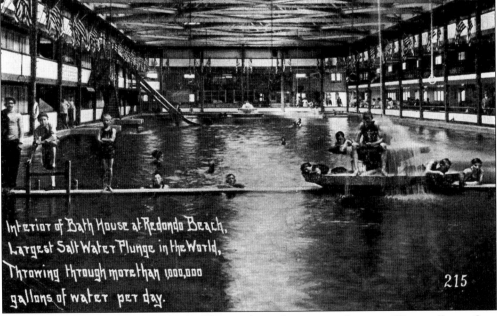

Interior of Bath House at Redondo Beach, Largest Salt Water Plunge in the World, Throwing through more than 1,000,000 gallons of water per day.

215

BATH TIME. The interior of the bathhouse shows how more than a million gallons of sea water each day could fill the largest saltwater plunge in the world. Spectators sat in the upper balconies. The bathhouse boasted an Olympic-size pool, a standard pool, and a place to wade, as well as a fountain. The pools were heated by Pacific Light and Power's steam plant just down the street.

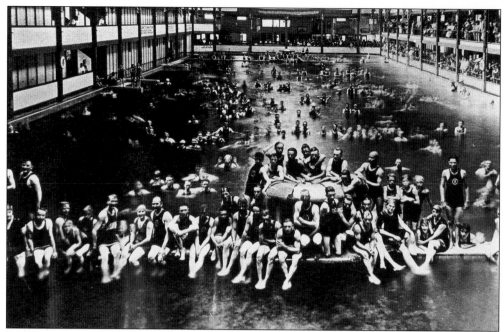

BATHHOUSE INTERIOR. The Plunge, as the pool in the bathhouse was called, could accommodate 2,000 bathers. The first bathhouse was replaced in 1909 by one in Moorish style to match the pavilion next door. During the early 1940s, the pool was filled in and used as a parking lot.

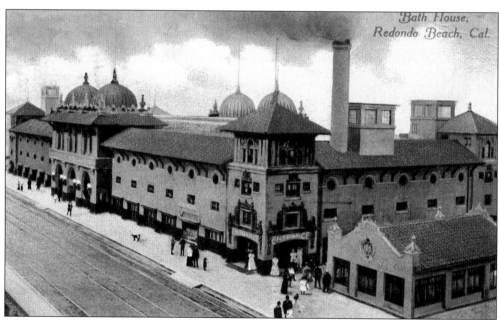

ANOTHER VIEW. Postcards of the bathhouse were popular, especially with visitors who had never seen the ocean, much less an enormous pool within steps from the beach. This card, mailed in 1910 to a man in Kansas, comments on how luxurious it felt to "spend hours" in the saltwater pool.

48

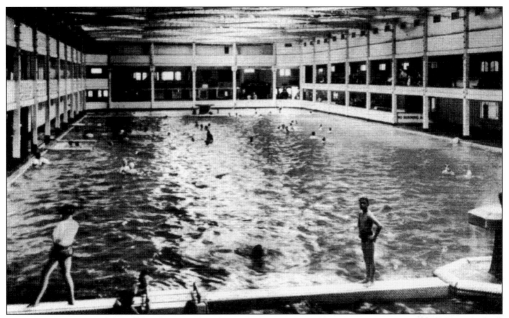

POPULAR POOL. After a dip in the Plunge, people could go to the nearby casino for a game or to the German chalet-style restaurant next door.

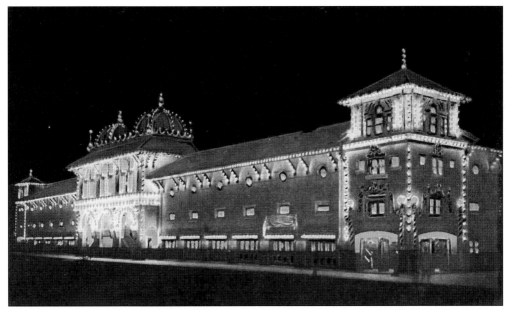

AT NIGHT. The bathhouse was lighted during the evening, giving the illusion of a pleasure palace floating against the night sky.

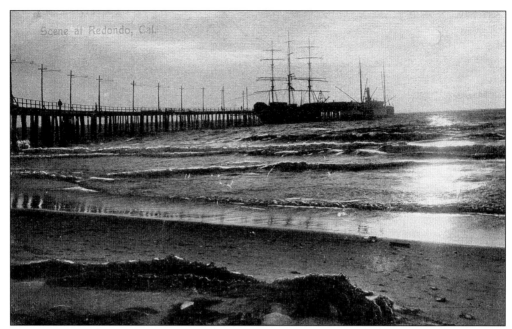

LATE EVENING SCENE. The full moon illuminates the pier, with sailing ships docked at the end.

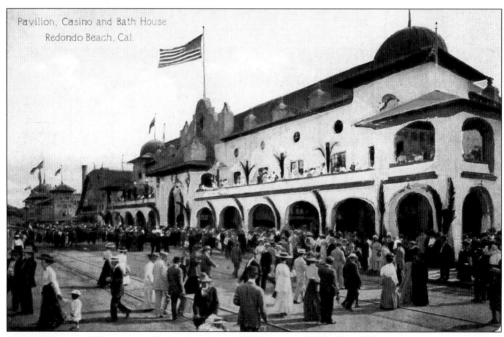

GALA CROWD. Life was usually festive along El Paseo. In 1906 a $1 million contract was awarded to Pacific Light and Power Company, making it the "greatest steam plant west of New York," allowing them to provide power for Redondo Beach's variety of attractions.

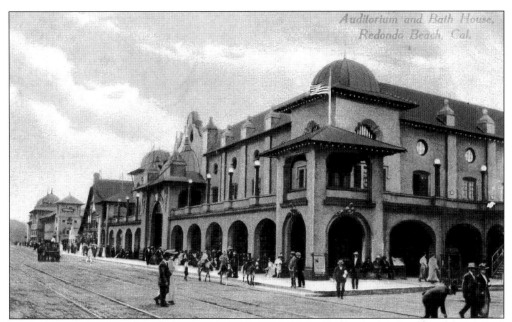

NEXT DOOR. Adjacent to the bathhouse was the auditorium, or pavilion, as it was also called. In 1905 industrialist Henry Huntington bought the Los Angeles and Redondo Railroad, making it part of the Pacific Electric and allowing residents of Los Angeles County to ride the red cars out to the beach to enjoy Huntington's other attractions. He sold his interests in the Hotel Redondo and the Pacific Electric railroad in 1910.

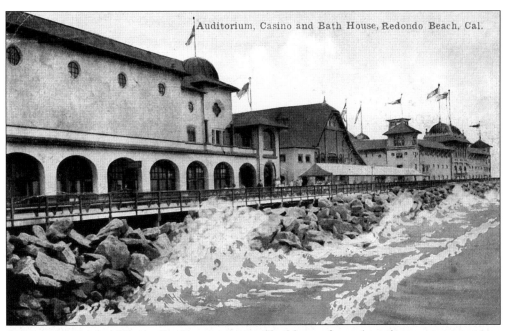

ALONG THE SHORE. The auditorium, casino, and bathhouse formed one long area, convenient to all who visited. This postcard was written by a woman commenting on "large crowds of people" along the beach in 1900. The gaming houses and amusement area was called the Midway before 1913, then it became El Paseo.

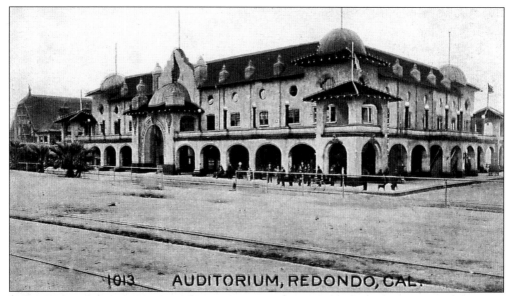

AUDITORIUM, REDONDO, CAL.

AUDITORIUM. Development of Redondo Beach as a pleasure resort was constant throughout its early years. Even though it started as a port-of-call, the attraction of its amusement facilities was strong and survived the decline of the port. A key feature of the pavilion was the Mandarin Ballroom, which seated up to 4,000. Major entertainers were booked in the ballroom months ahead, such as Austrian-born contralto Madame Ernestine Schumann-Heink, who drew admirers from throughout the area. The ballroom was on the second story and featured a beech wood dance floor with space for 500 couples.

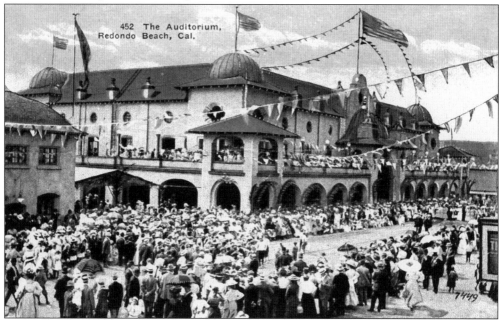

452 The Auditorium, Redondo Beach, Cal.

CROWDS, CROWDS, CROWDS. The tourist trade flourished. Advances in transportation during the last half of the 19th century contributed enormously to the development of the American city in general and the growth of Redondo Beach in particular. Note the arched promenade that surrounded the complex.

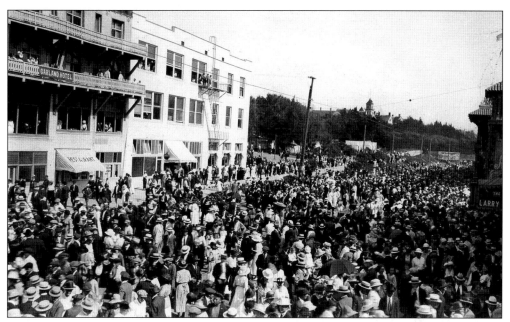

EVERYONE TURNS OUT. Special events in Redondo Beach always drew crowds. In August 1917 the combined Pier Day and Harbor Day celebrations brought people from miles around, including film star Mary Pickford and her husband Owen Moore, who arrived in a limousine.

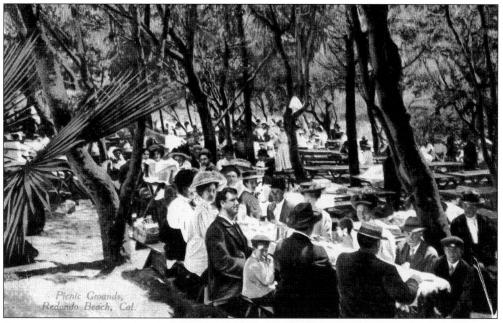

SUNDAY IN THE PARK. Picnic baskets were laden with all sorts of homemade goodies for the regular outings. Men wore hats, women dressed. No leisure clothes for these turn-of-the-century folk. Near the Elks Club, this park was used by for state reunions. Iowa and Kansas were the most popular.

IOWA PICNIC. March 1910 is the date on this Iowa picnic postcard written to a friend in Butler, Iowa. The writer says, "We were snapped at the Iowa picnic and wish you could have been in the group. Weather is fine. Fishing Tomorrow."

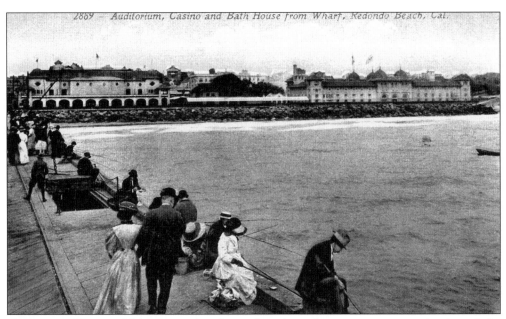

FROM THE WHARF. This perspective shows show how the amusement area dominated the coastline. Women wore bonnets and blouses with leg-o-mutton sleeves. Men were fashionable with their derbies.

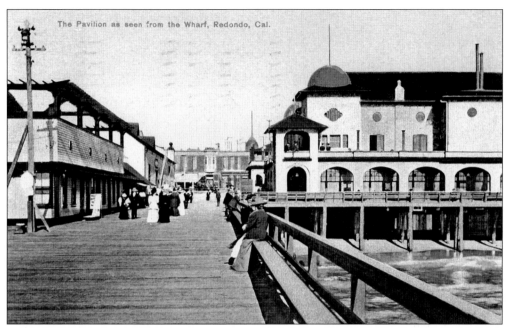

DIFFERENT ARCHITECTURE. This card was postmarked November 27, 1908, and sent to a woman in Chicago. The writer comments on how different California architecture is from that found in the Midwest.

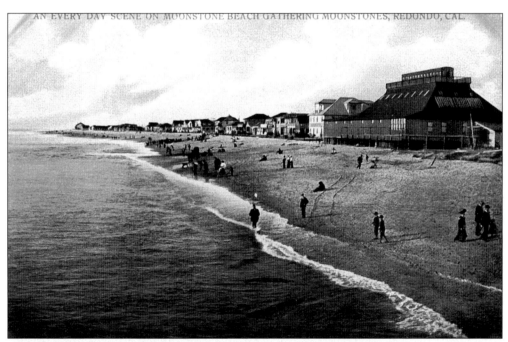

AN EVERY DAY SCENE ON MOONSTONE BEACH GATHERING MOONSTONES, REDONDO, CAL.

GATHERING MOONSTONES. Moonstone Beach was just north of today's Fisherman's Wharf and had mounds of the gemstones up to 20 and 30 feet wide. Picking up the treasure was a popular pastime as amateurs and gemologists alike were drawn to their mysticism. The stone belongs to the large mineral family of feldspars that provide almost two-thirds of all stones on Earth.

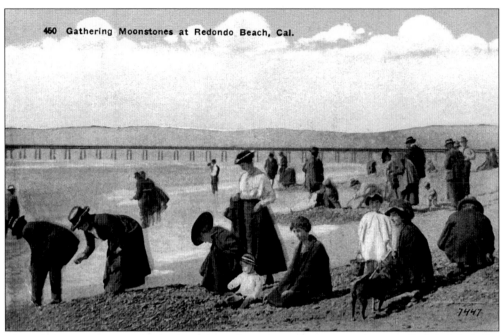

450 Gathering Moonstones at Redondo Beach, Cal.

MORE MOONSTONES. The Redondo Beach variety of moonstones was called "adularia," a silicate of potassium aluminum. Another synonym for moonstone is Selenite, from the Greek goddess of the moon, Selene.

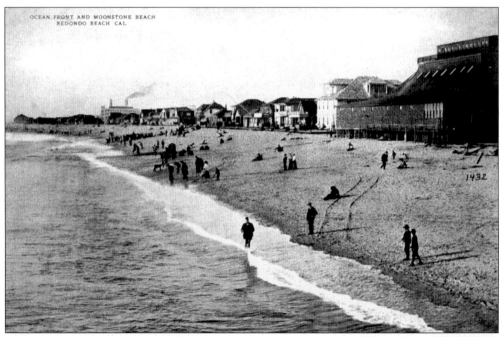

OCEAN FRONT AND MOONSTONE BEACH
REDONDO BEACH CAL.

SCENE AT MOONSTONE BEACH, 1914. When uncut, moonstones look quite boring, which makes it difficult to discern the attractiveness brought out by a cutter's expertise and skill. Houses and shops bordered the Moonstone Beach.

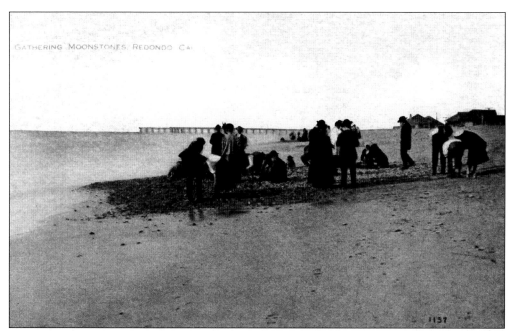

HATS AND MOONSTONES. Men wore hats and coats to gather moonstones in Redondo Beach in the early 1900s. Unfortunately, most of the moonstones were ground into construction material as the oceanside resort yielded to commercial demands.

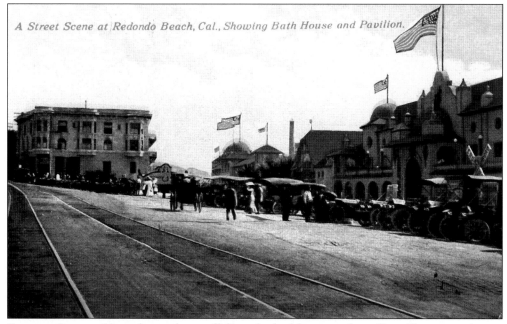

STREET SCENE. Note the tracks paralleling the bathhouse and pavilion. Transportation to Redondo Beach's amusement area was convenient and inexpensive.

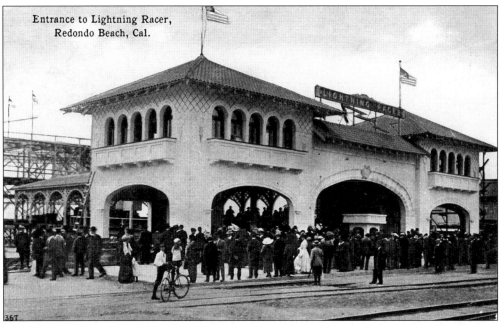

LIGHTNING RACER. Hovering high above the beach amusements was the gigantic Lightning Racer, a roller coaster of immense proportions. The postcard is addressed to a woman in Philadelphia and bears a February 1920 postmark. The writer expresses disbelief at the warm weather, calling February in Redondo Beach "a constant summer's day."

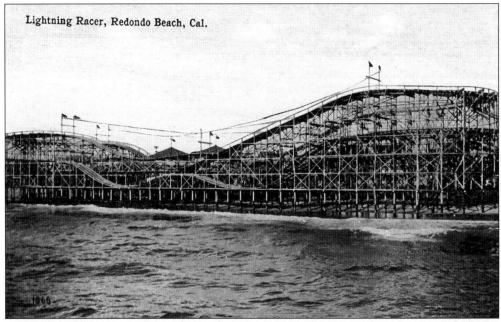

LIKE A PREHISTORIC BEAST. School children in the area called the Lightning Racer their own pet monster, likening it to a dragon from mythical tales. The ride was built in 1913 with more than a mile of track. Its 6,000 feet had a tingling combination of swoops and dips. It suffered from storms and overuse and ironically, was the target of a lightning strike and fire. It was located between Beryl and Coral Way on El Paseo.

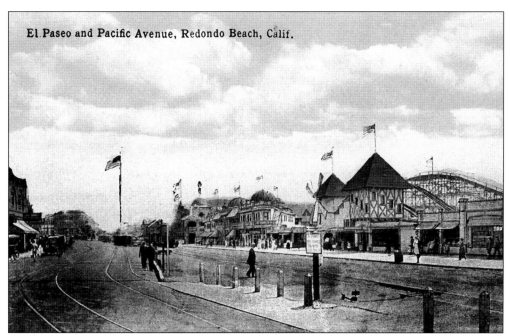

El Paseo and Pacific Avenue, Redondo Beach, Calif.

PASEO AND PACIFIC. The early chamber of commerce promoted Redondo Beach as being "on the rim of the western sea." Note how the Lightning Racer is visible from throughout the area.

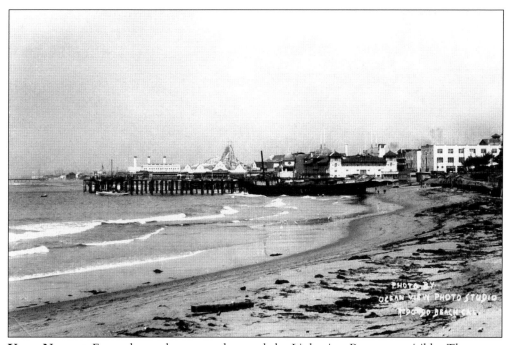

VIEW NORTH. From shore, the steam plant and the Lightning Racer are visible. The steam plant provided electricity for the growing town and women were encouraged to use the new energy source for cooking.

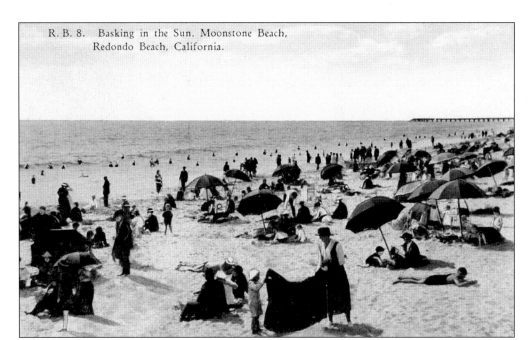

BASKING IN THE SUN. The weekend had become popular in the United States by 1910 as companies began to give employees a day off to be with their families. The 1910 census shows the United States population at 91.9 million, with fewer than half of the adult population having earned a high school diploma. By 1910, Redondo Beach's population was nearing 15,000 and the town had a high school.

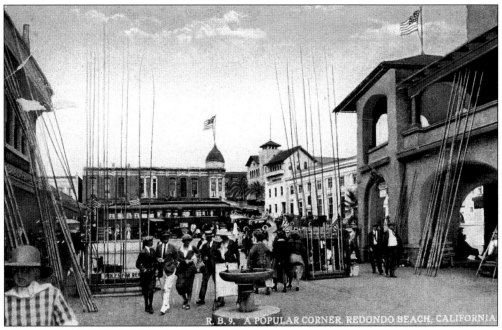

FISHING POLES. Fishing was always a popular way to spend time, whether it was to catch something for dinner or to spend away the afternoon in the sun down by the pier. Note the long bamboo fishing polls.

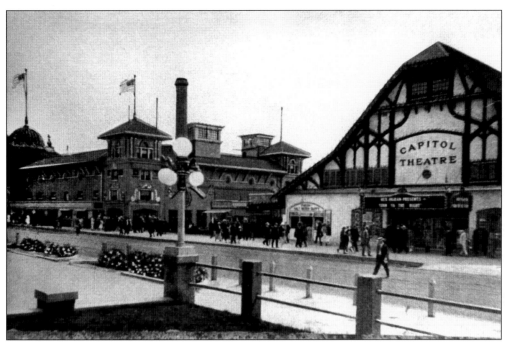

CAPITOL THEATER. This 1924 view of the Capitol Theater shows how popular the El Paseo amusement area had become. At the left is the plunge, with the casino down the street to the right. The Capitol later was renamed the Art Theater.

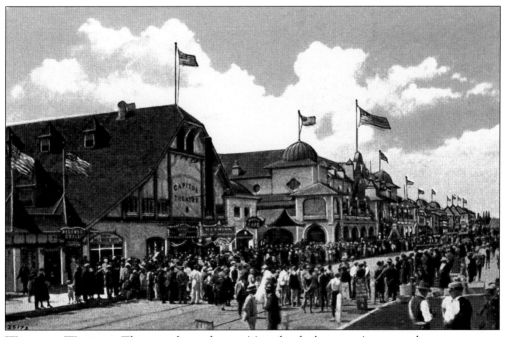

WAITING, WAITING. The crowd may be awaiting the day's entertainment palaces to open or perhaps some are in line for a seat at one of the amusement area restaurants. Just down the street are the Capitol Theatre and the pavilion.

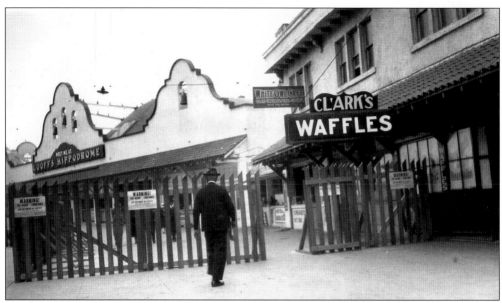

THE HIPPODROME. The famous 1912 Looff carousel was the main attraction of the Hippodrome along El Paseo. Charles I. D. Looff began designing and building carousels in 1895 and his creations were recognized nationally as true masterpieces of wood sculpture. The Redondo Beach carousel was owned and operated by Looff's son, Arthur, who tried unsuccessfully to move it to Long Beach in 1940. When his lease was not renewed in Redondo Beach, the carousel was placed in storage. By the time it was purchased in 1960, many of the figures had vanished.

JANUARY 8, 1911. It's the date on this picture that was printed as a postcard by Baldwin Studio in Redondo Beach. The photographer was the husband of the woman in the center. Her message to the recipient apologizes for the sun being "so strong as to prevent this from being a good photo."

Five

PIERS AND POLES

By the time Redondo Beach was incorporated in 1892, two events had occurred that shaped the harbor's history. The first was the sale of more than 400 acres of beachfront land by the Dominguez Estate Company for $12,000, and the second was the discovery of the Vicente Submarine Valley immediately offshore of the newly acquired tract. With lumber coming from the Pacific Northwest, a harbor had to materialize. The Pacific Coast Steamship Company's steam lumber schooner *Eureka* was the first to arrive with redwood to build a pier.

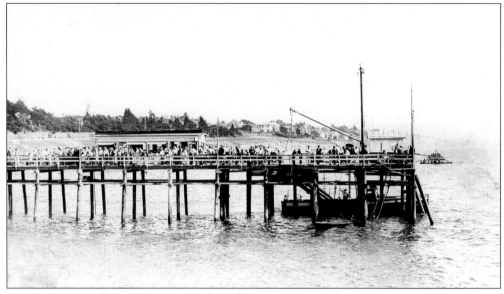

SIMPLE FISHING PIER. No souvenir shops for the tourists or fancy restaurants, this early pier attracted those who wanted their catch-of-the-day to feed the family or to be a snapshot to show the folks back home how they caught the big one.

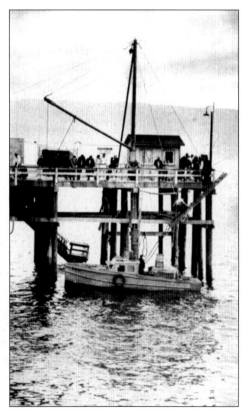

MONSTAD PIER BOAT LANDING. This all-purpose pier accommodated shipping, boats, and fishermen. By the end of the 20th century, Redondo Beach had seen seven different piers and three wharfs. The first wharf was built in 1889 at the foot of Emerald Street. It was ripped apart by a storm in 1915 that chalked up winds of 85 miles an hour and left 14 inches of rain. Wharf No. 2, off Ainsworth Court, had a Y shape, one for the railroad and the other for fishing that joined 100 yards out. Wharf No. 3, built in 1903, was at the foot of Sapphire Street and stretched 460 feet. Even with multiple wharfs available, the lumber business was so brisk in those days that it was not uncommon to see ships lined up for a berth. Wharf No. 3 was dismantled in 1925.

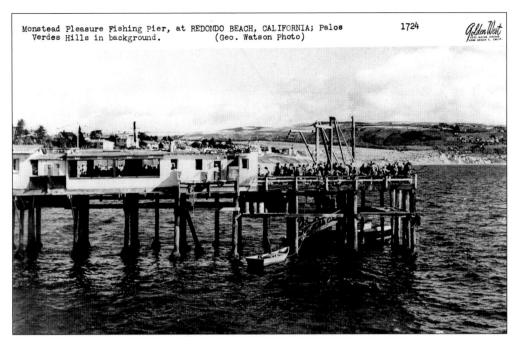

FISHING OFF MONSTAD. Fishermen jam the end of the Monstad Pleasure Pier. Note the boats tied alongside, and Palos Verdes Peninsula in the background.

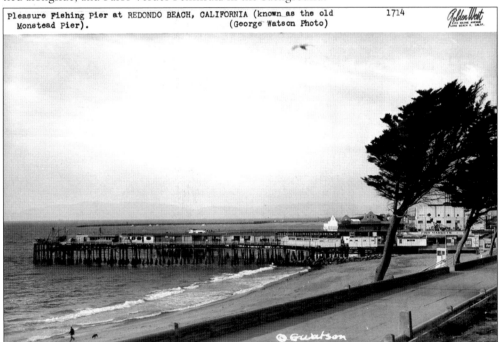

OLD MONSTAD PIER. On November 30, 1925, the Redondo Beach City Council unanimously voted to give Capt. Webb N. Monstad a 20-year franchise to build a pier at his own expense. The project from the southern side of the municipal wharf could be used as a boat landing and for fishing. As a private enterprise, it relieved the city of financial responsibility. The foreground was the site of the Irons Cottage Restaurant.

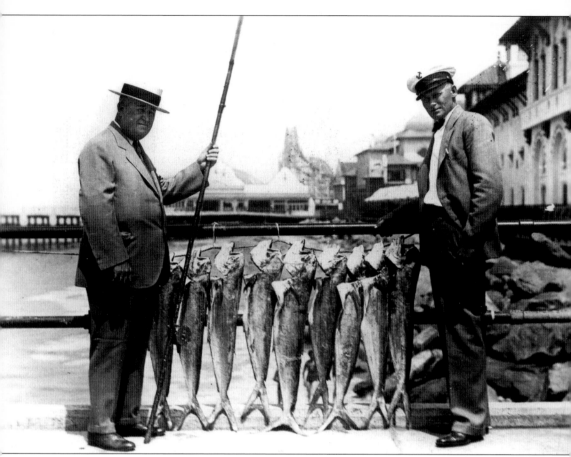

MONSTAD'S CATCH. Captain Monstad (left) shows off his day's catch against the pier in this 1930 scene.

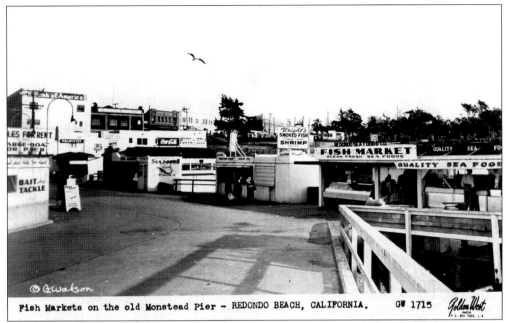

Fish Markets on the old Monstead Pier – REDONDO BEACH, CALIFORNIA. GW 1715

FISH MARKETS. The old Monstad Pier was an easy place to find fish, bait, and tackle. This scene from 1930 shows the Bank of America just behind the pier. Youngsters in the area could use homemade screens to catch the softshell crabs and sell them to the Monstad Pier bait shops for 10¢ a dozen. The shops then charged 25¢ a dozen.

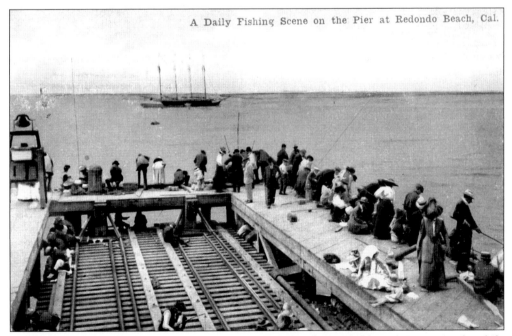

A Daily Fishing Scene on the Pier at Redondo Beach, Cal.

1890s SCENE. Typical of scenes on the pier in 1890, this shows children sitting patiently while adults fished for dinner. Tracks ran from the shore to the end of the pier. Sent to a woman in Oakland, California, this card comments on "how great the fishing is."

67

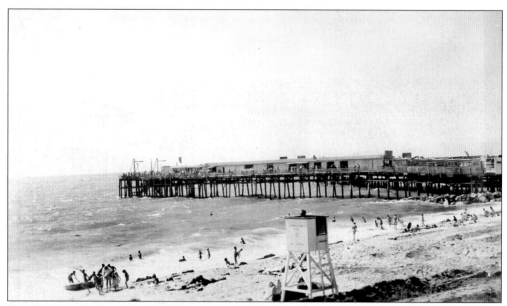

PIER STRETCHES OUT. By the turn of the century, people bought bait on the pier and tried their luck. Fishing was usually good enough to provide dinner for an entire family. Note the lifeguard station in the foreground.

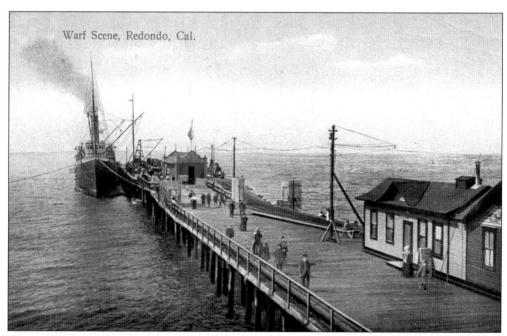

Warf Scene, Redondo, Cal.

EARLY 1900s SHIP ARRIVAL. Most postcards in this era were printed in Germany, which explains the spelling of "warf" on the front of this card.

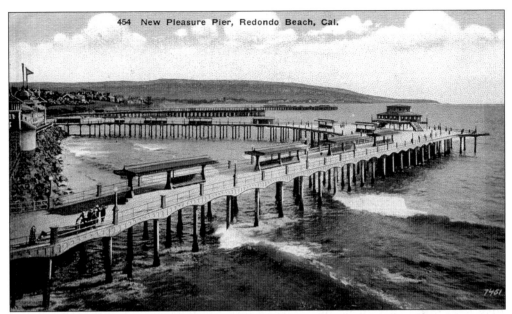

454 New Pleasure Pier, Redondo Beach, Cal.

NEW PLEASURE PIER. A new pier in Redondo Beach meant new vendors, new restaurants, and new places for the fishermen to cast their lines. On April 8, 1933, with Prohibition over, the newly allowed "3.2 beer" (3.2 percent alcohol) was first sold in cafes dotting the shoreline. Crowds packed the Mandarin ballroom and the hotels and cafes on Pacific Avenue. A steady stream of cars passed through the city with drivers stopping to taste the new beverage.

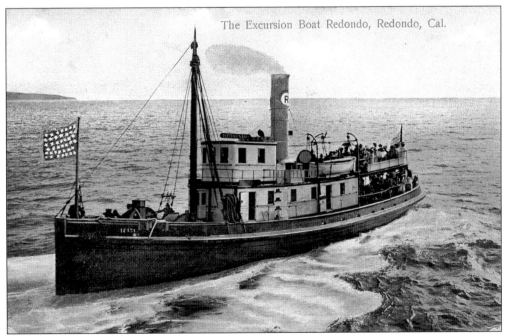

The Excursion Boat Redondo, Redondo, Cal.

EXCURSION BOAT *REDONDO*. This January 1919 postcard to a friend in San Diego mentions that "the boat ride was perfect and we saw whales."

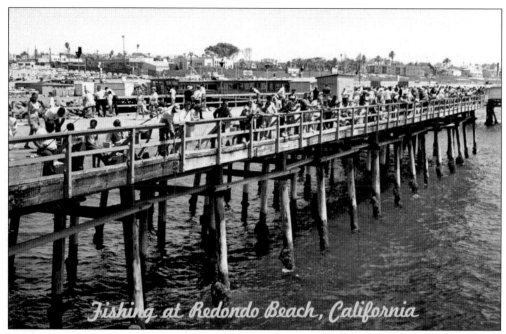

EVERYBODY FISHES. Early promotional postcards pushed the popularity of fishing from the Municipal Pier. Halibut and yellow tail were plentiful. Mackerel could be caught with just a shiny hook, no need for bait.

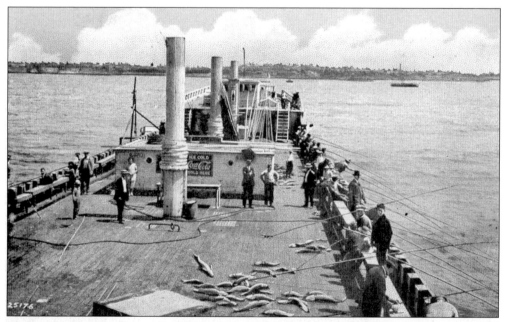

FISHING BARGE. The four-masted fishing barge, the *Fullerton*, was billed as the largest in the world and operated out of the Redondo Beach harbor in the 1920s. The barge usually anchored a mile off the coast where the waters yielded yellow tail, mackerel, and sand sharks. Printing on the back of this postcard reminds the sender that the 1¢ postage is for Cuba, Canada, and Mexico.

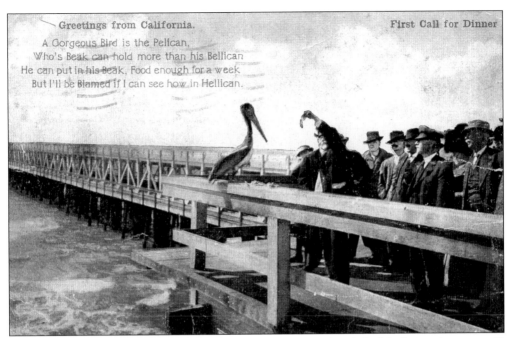

PELICAN WATCHING. This card was sent to a man in Pennsylvania by his sister, who wrote, "I saw a scene just like this yesterday morning on the pier. The pelican swallowed the fish whole as the people threw them."

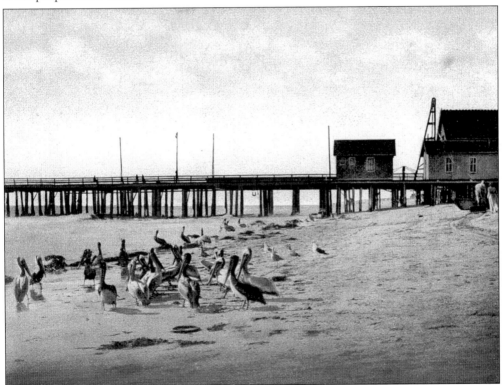

WHAT'S FOR LUNCH? Pelicans hurry to pick up picnickers' scraps.

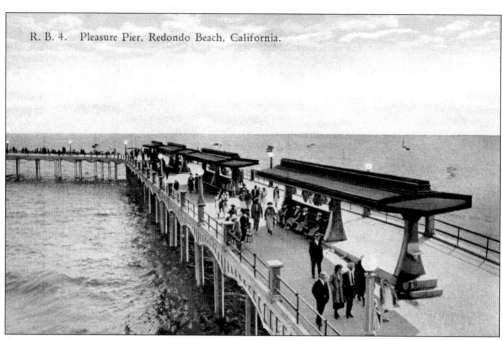

R. B. 4. Pleasure Pier, Redondo Beach, California.

PLEASURE PIER. Skirts are beginning to be shorter in this 1920s view from the Pleasure Pier.

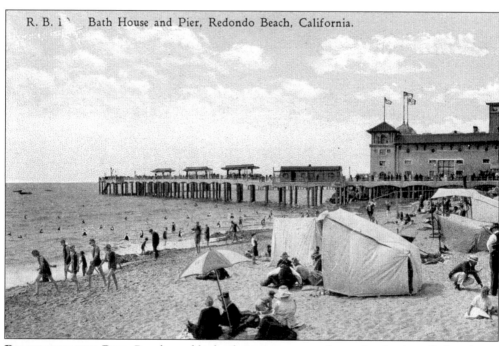

R. B. 1 Bath House and Pier, Redondo Beach, California.

BATHHOUSE AND PIER. People could take their own tents to the sand and enjoy a little privacy. At night, the strains of music from the nearby amusement area wafted across the beach.

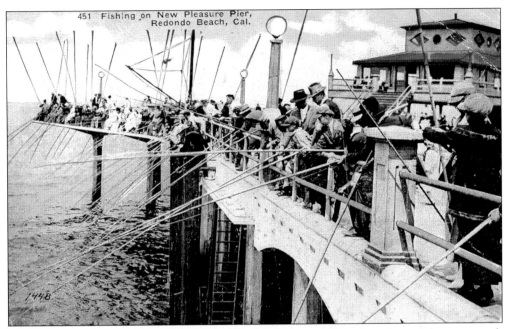

CONCRETE PIER. Fishing was always good off the concrete pier when the weather was good. Cut mackerel was the bait of choice. This postcard to a friend in Laguna comments on the good time the writer is having and ends with the standard, "Wish you were here."

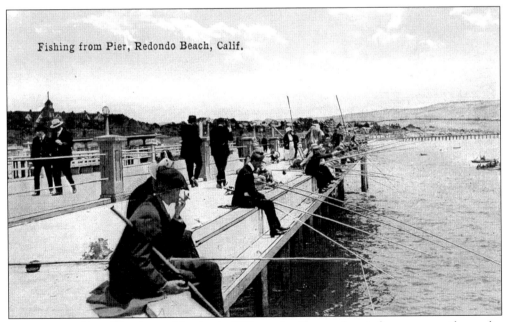

DRESSED TO FISH. The dress of the day in 1918 required hats and coats for men, even those who spent a leisurely day on the pier. The hills of the Palos Verdes Peninsula are in the upper right.

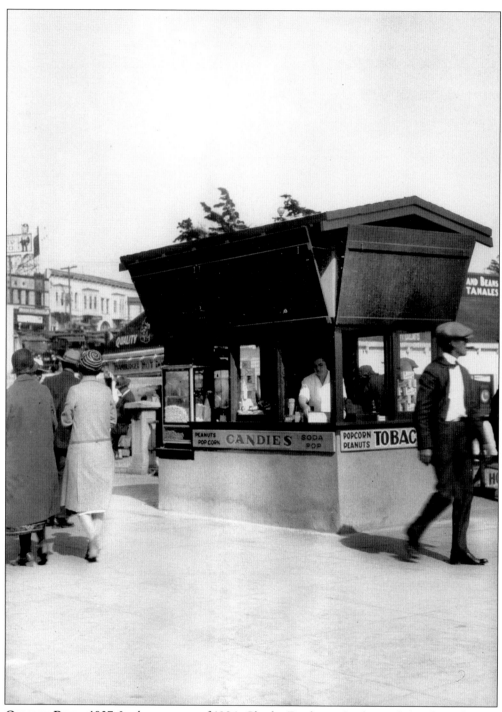

ON THE PIER, 1927. In the summer of 1926, Charles Doyle received permission from the city to build this popcorn stand under a pergola on the pier. The stand was barely ready for the July 4th crowd, and the day's take was "something over $100 bucks," as Doyle's son Chet recalled. That was a lot of in those days, when popcorn, soda pop, and candy bars went for a nickel. The city later decided that the pier was unsafe and the stand had to be moved.

Six

STORMY WEATHER

Redondo Beach's original harbor featured piers out to the open sea with no shielding breakwater, which meant that when the weather turned the harbor became a pocket to catch the northwest wind and rolling waves of crushing violence. Even though in the 1890s Redondo Beach was the principal shipping port for Southern California, it wasn't all smooth sailing. In the official "Wreck Reports" filed for the area, most of the disasters centered on Redondo Beach during the years 1888 to 1917, when at least 11 ships were wrecked. A handbook for ship owners, masters, and agents described Redondo as "an open roadstead, wide open to the sea and not totally protected."

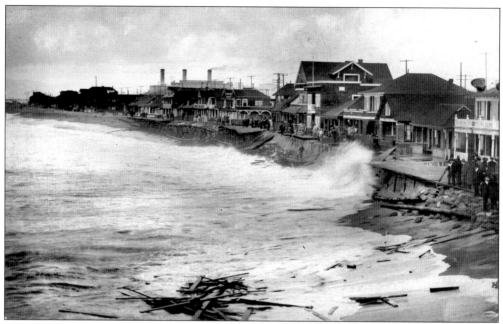

1915 Storm. Waves crash into the beach during a winter storm in 1915. Note the stacks from the Edison Company in the background.

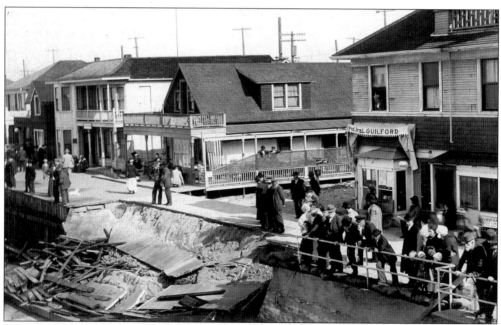

Storm Watchers. A curious line leads to the beach to see the ravages of the March 28, 1915 storm.

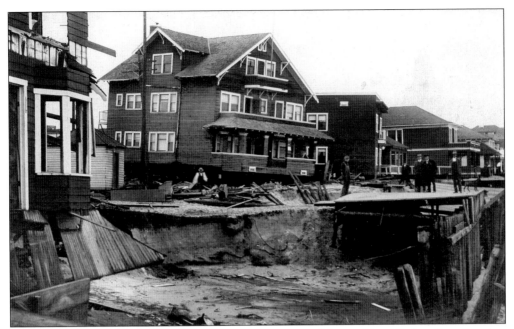

GRANDMOTHER CLOTWORTHY. A 1915 storm victim, this was identified as Grandmother Clotworthy's house on the Strand. It was later moved to the northwest corner of Broadway and Carnelian. The storm washed out most of the area in front and trashed the house to the left.

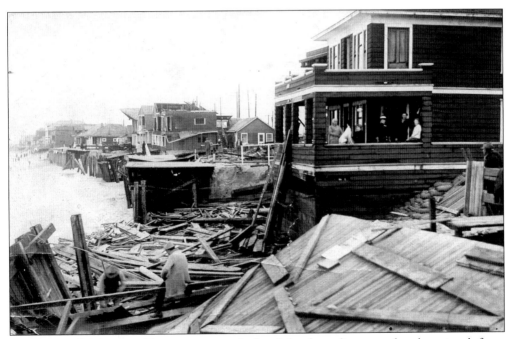

MORE OF 1915 STORM. Houses were wrecked and the shore disappeared under nature's fury.

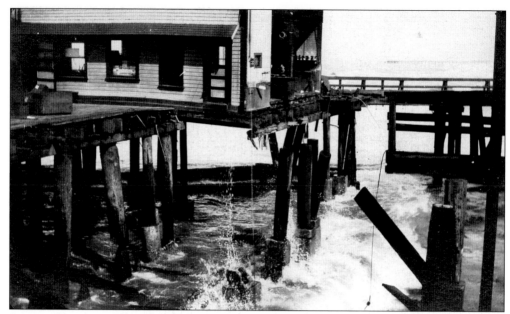

STORM DESTROYS PIER. Nothing could withstand the more than 80-mile-an-hour winds of the 1915 storm. Photographers rushed to the scene to make postcards for the locals to send to families back east.

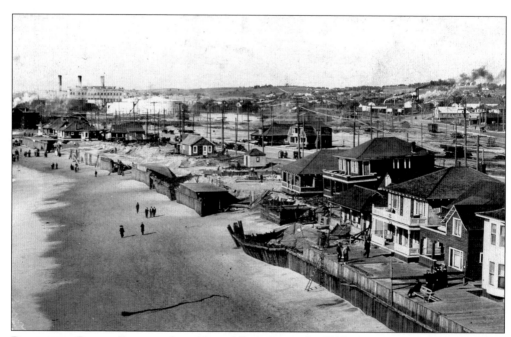

BATTERED COAST. Fences and sand bags fell victim to the 1915 storm.

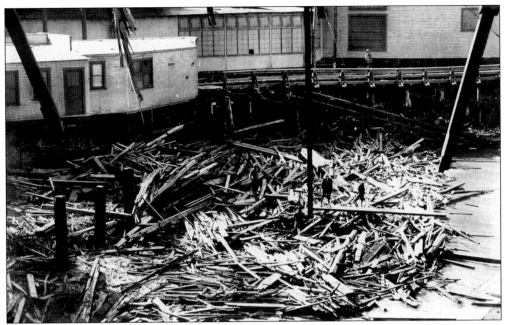

WHAT HAPPENED. The writer of this postcard points out that "this is what the ocean did." Protective fences were splintered by the force of the waves.

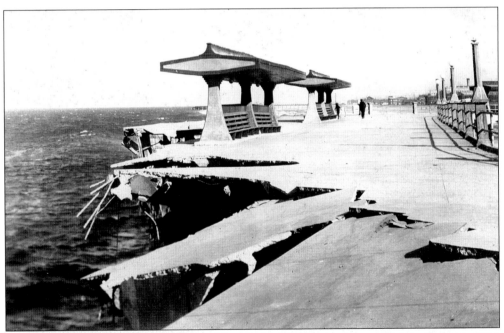

NOT PRETTY. The entire end section of the reinforced concrete pier was lost in the severe 1919 storm; not much was left during the fierce winter storms. A more stable harbor came closer to reality in 1917 when voters approved $300,000 in construction bonds. But that project was contingent on plans of an eastern shipbuilding company that went broke before the proposed harbor got off the drawing board.

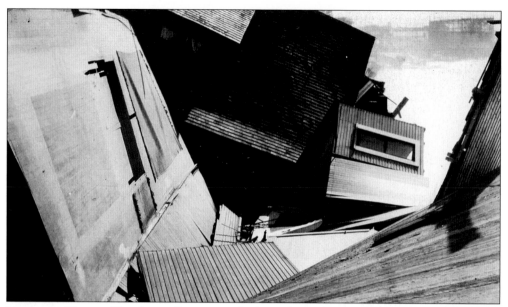

TUMBLED HOUSE. The furor of nature washed out the underpinnings and swept supporting sand out to sea.

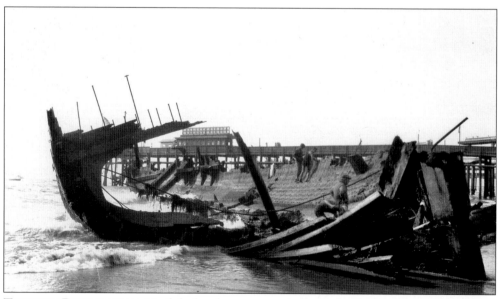

TERRIBLE DESTRUCTION. Until the breakwaters were built, Redondo Beach had no protection from winter Pacific storms.

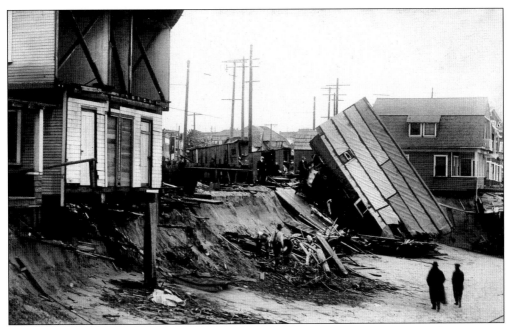

NO INSURANCE. There wasn't much the homeowners along the beach could do when a winter storm roared ashore. A reported three houses in the 1914 storm were washed out to sea.

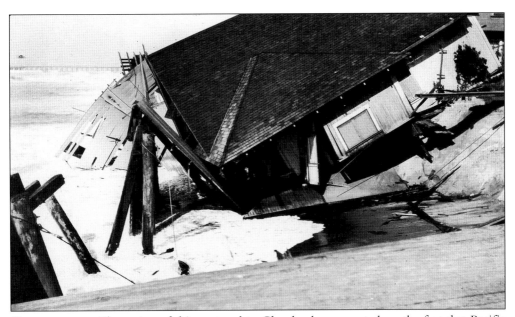

UPSIDE DOWN. The writer of this postcard to Cleveland commented on the fact that Pacific storms "really do cause distress."

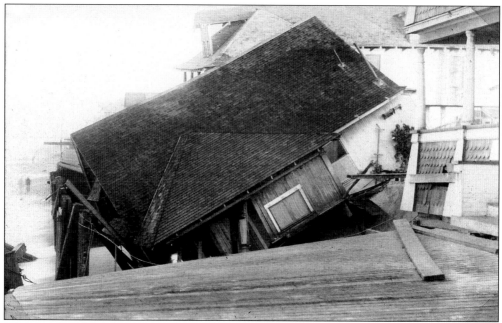

NOTHING SAVED. Even though residents in the early years salvaged what little they could, most simply let the sea claim its victims. The beaches were storm victims, too, with natural replenishment taking up to two and three years.

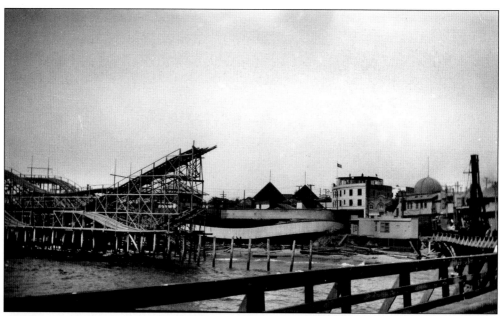

LIGHTNING RACER. The popular roller coaster, the Lightning Racer (also known as the Big Dipper), suffered heavy storm damage as wind and rain toppled the wooden structure in the 1919 storm, but it was soon rebuilt. The El Ja Arms Hotel is pictured at right.

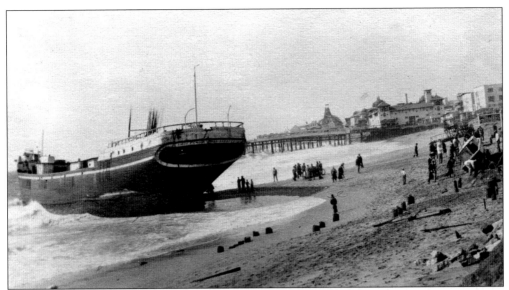

1930 STORM. The aftermath of a dreaded 1930 storm left this ship ashore near the base of Pearl Street. The Monstad Pier and saltwater plunge may be seen in the background.

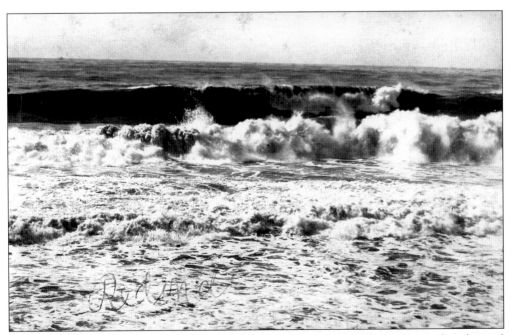

STORM AT SEA. Just about every storm to hit Redondo Beach in its first 100 years has churned up waves crashing into the beach. As late as 1987, the city began applying for permits to dredge the harbor and attempt to prevent the creation of two main shoaling areas. The 1988 storm caused major damage, including a breach of the breakwater with further shoaling occurring.

SMOOTH SAILING. This postcard shows the waters off Redondo Beach in more peaceful days. It was written to a friend in Fullerton by a woman who says, "We came down to see what land is here before we sell our home."

Seven

GRAND OCCASIONS

Easter Sunday, April 23, 1908, was a day like no other for 16-year-old Redondo Beach. With the ocean calm under a perfect blue sky, the town greeted the Fourth Division of the Atlantic fleet, also known as Pres. Theodore Roosevelt's Great White Fleet. The flagship *Alabama* rounded Point Vicente at 7:15 a.m. to the cheers of the gregarious crowd lining the Palos Verdes Peninsula cliffs and the Redondo Beach shore.

The other three battleships of the Fourth Division and all four ships of the Third Division followed in single file. All wheeled about and steamed shoreward, four abreast. Then the eight ships passed north in single file, with a salute for each ship fired from Wharf No. 1. Military and Salvation Army bands played throughout the day.

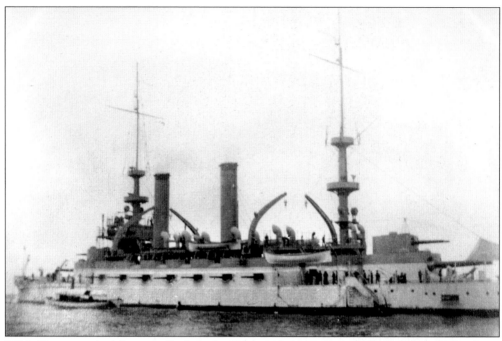

USS *Kearsarge*. After parading up the Santa Monica Bay several miles from Wharf No. 1, the *Kearsarge, Illinois,* and *Kentucky* anchored alongside the USS *Alabama,* about 500 feet from shore.

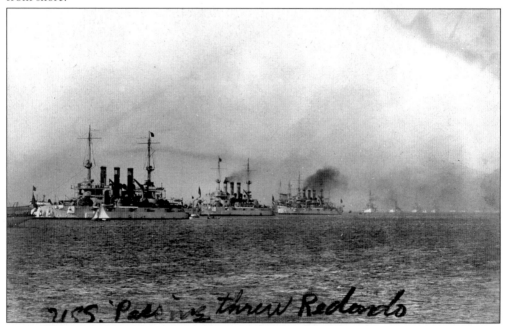

Passing Redondo. The Great White Fleet, sent around the world by Pres. Theodore Roosevelt from December 1907 to February 1909, consisted of 16 new battleships of the Atlantic Fleet. They were painted white except for gilded scrollwork on their bows. The 14-month voyage was a grand pageant of American sea power. The squadrons were manned by 14,000 sailors. They covered some 43,000 miles and made 20 port calls on six continents.

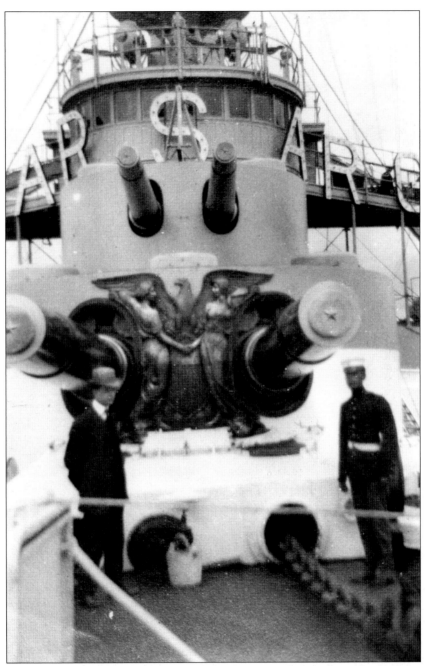

LOCAL OFFICIAL INSPECTS. An unnamed local dignitary was part of the welcoming delegation to honor the USS *Kearsarge*. After refitting in California, the ship crossed the Pacific to visit Australia, New Zealand, the Philippines, and Japan. The *Kearsarge* returned to the United States in February 1909 at the conclusion of a homeward-bound voyage that took her through the Indian Ocean and the Mediterranean. She was decommissioned in September 1909 for modernization that included fitting new "cage" masts and other improvements. The battleship was only occasionally active during the next several years, largely on training duties, but also serving off Mexico in 1915 and 1916.

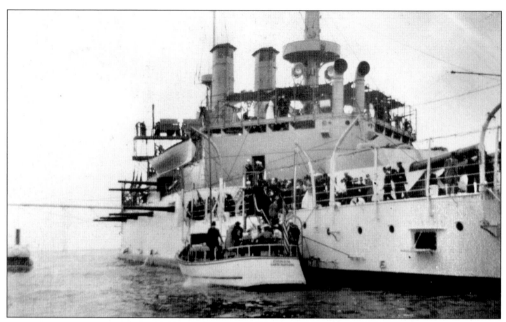

USS *ALABAMA*. A member of the Great White Fleet, the *Alabama* was the flagship for the Division 1 Battleship Force during World War I. She was decommissioned in December 1921 and was transferred to the War Department for use as a target in experiments in aircraft bombing.

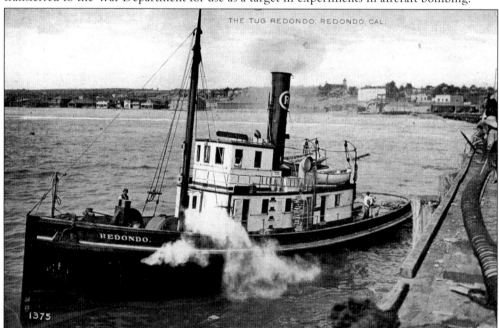

TUG *REDONDO*. The Tug *Redondo* was a major feature of the Great White Fleet's visit as it took 100 passengers for a three-hour cruise around the bay, giving passengers the opportunity to view the fleet maneuvers. Many humorous incidents were reported throughout the day as the sailors were given leave to enjoy the waterfront amusements. Some hid with their girlfriends in the Santa Fe boxcars or under the wharf to keep out of sight of the provost guard. By midnight, all of the sailors had left the pavilion in obedience to the posted orders.

CALIFORNIA **DROPS BY**. A year before the Great White Fleet paraded in front of Redondo Beach, the residents enjoyed a visit by the USS *California*, a cruiser built by San Francisco's Union Iron Works. She was commissioned in August 1907 and spent the next four years along the West Coast, sharpening her readiness through training exercises and drills. She was renamed the *San Diego* in September 1917 and became the flagship for the Pacific Fleet.

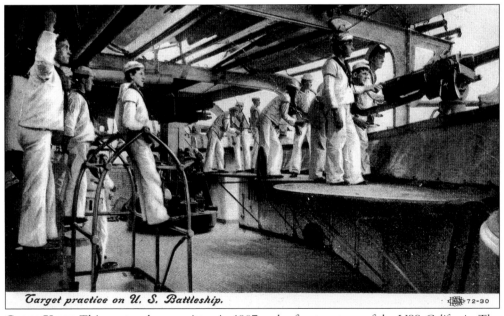

Target practice on U. S. Battleship.

CLASS VISIT. This postcard was written in 1907 and refers to a tour of the USS *California*. The writer tells a friend in Missouri, "Our school went to visit the war ship yesterday off Redondo and I got you this postal. The ship is simply grand."

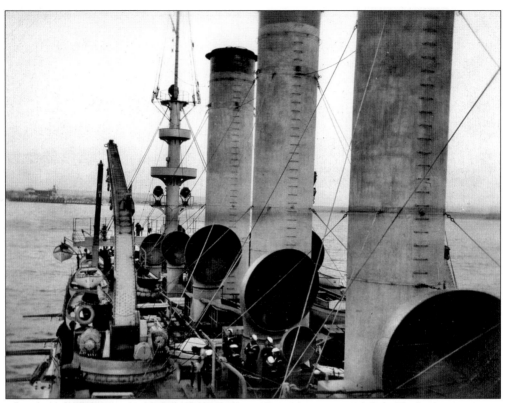

USS MARYLAND. The USS *Maryland* visited Redondo Beach in 1918 shortly after it was commissioned. With the first 16-inch guns mounted on a U.S. ship, the *Maryland* was the pride of the Navy. After an East Coast shakedown, she found herself in great demand for special occasions. After fleet exercises off the Panama Canal Zone, the *Maryland* transited the canal to join the battle fleet stationed on the West Coast.

MASTS AND SAILS. Residents along Redondo Beach's shoreline enjoyed viewing the ships as they glided into port, bringing passengers for the hotels or merchandise for the growing business district. By 1922, more than 70 percent of the vessels that traded here used oil rather than wind power.

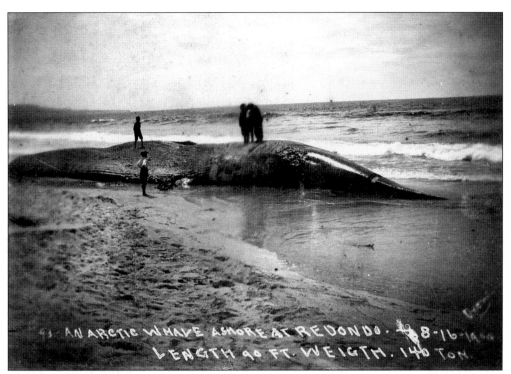

1900 WHALE. On August 6, 1900, an Arctic whale washed ashore in Redondo Beach. It measured 90 feet long and weighed 140 tons.

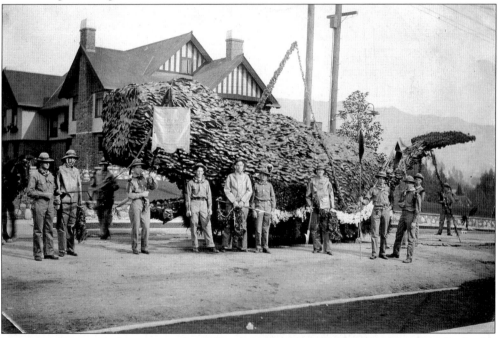

INSPIRED FLOAT. Perhaps it was the 1900 whale that inspired Redondo Beach's entry in the 1908 Rose Parade in Pasadena. The floral whale, made of kelp and ivy, was assembled by local residents who wanted to be part of the gala parade.

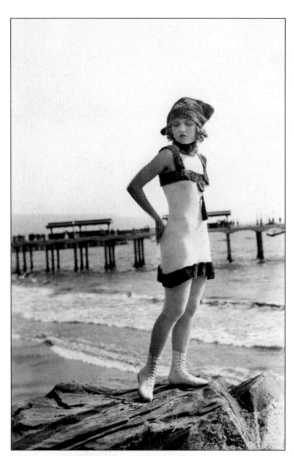

PIER SCENE, 1919. Was she a Hollywood hopeful or just a tourist enjoying the Redondo Beach sea and sand with the pier in the background? The shoes indicate that she was not planning on much wading in the calm surf.

INDEPENDENCE DAY. The Fourth of July was always an occasion for celebration in Redondo Beach, especially by this group of the city's firemen, who decked out their 1920 fire truck with the red, white, and blue.

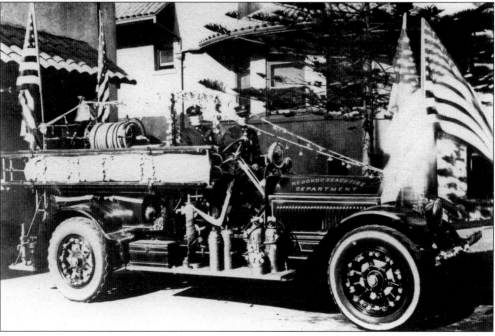

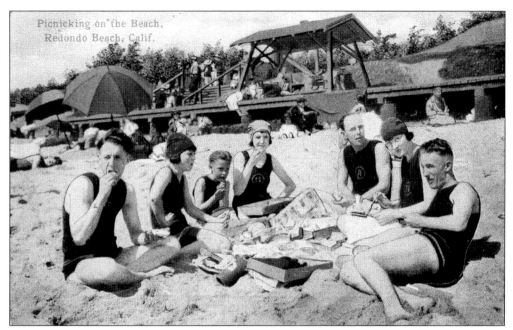

Picnicking on the Beach, Redondo Beach, Calif.

ANOTHER GRAND OCCASION. For beach picnickers, every outing was a perfect occasion for fun in the sun. Bathing suits were wool and bathing caps of the 1920s were meant to keep the sand out of the coif. A couple from Missouri honeymooned in the area in 1924 and sent this card to their parents.

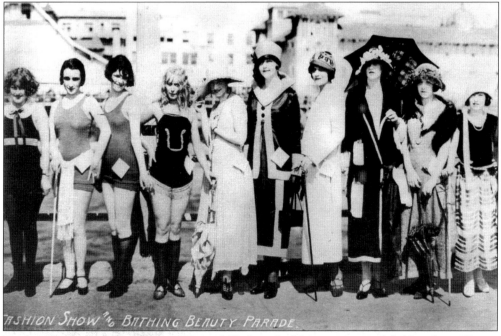

FASHION SHOW "%" BATHING BEAUTY PARADE.

LOVELY LADIES. This event in 1922 was billed as a bathing costume and fashion show. Young ladies from throughout the area flocked to Redondo Beach to see and be seen in the hopes that the movie industry would spot their talent. A newspaper account of the day reads, "Girls were ready to flash from motor to waves in colors rivaling the rainbow."

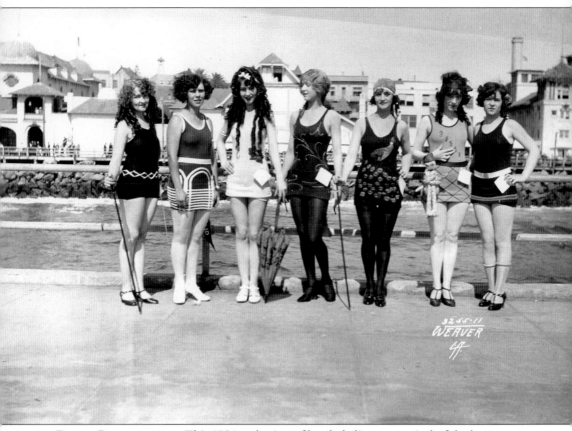

BEACH PULCHRITUDE. This 1924 gathering of lovely ladies was typical of the beauty contests of the day. Sponsored by clubs to draw visitors to the Redondo Beach El Paseo amusement area, the competitions attracted starlets from Hollywood as well as local talent.

Eight

OIL AND STEAM

Throughout Redondo Beach's early history, a mixture of business, industry, people, and projects provided an overlay of influence. As the community developed, these places and things overlapped, with one changing the direction of the other. This was especially true of the belching block of concrete at the northern end of the beach. As far back as 1897, the Redondo Steam Plant was a pioneer in power generation

Owned by the Pacific Light and Power Corporation, the power company expanded its capacity and in 1908 became the largest producer of electricity for Southern California's major source of transportation—the trolley car. By 1910, the demand for electricity from the railways and communities began outstripping the power supply, and in 1917 Pacific Light and Power Corporation merged with Southern California Edison.

ADJACENT TO THE SALT LAKE. The Redondo Steam Plant was adjacent to the old salt lake, a drainage basin from the ocean. The early Chowigna Indians used the salt for barter with other tribes, and Manual Dominguez saw its commercial worth when he inherited the property through the Spanish land grant.

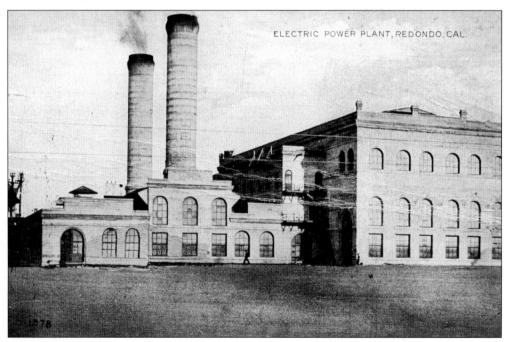

STEAM PLANT. Manual Dominguez sold the salt lake to the Pacific Salt Works in 1854 for $500, but that company was dissolved by a bankruptcy court order in 1862 and the land was acquired by Francis Mellus, a Los Angeles hardware merchant. By then, the Salton Sea salt works had become the industry leader and the Redondo Beach operation showed little profit. It was discontinued in 1881, and the area by the steam plant eventually was drained.

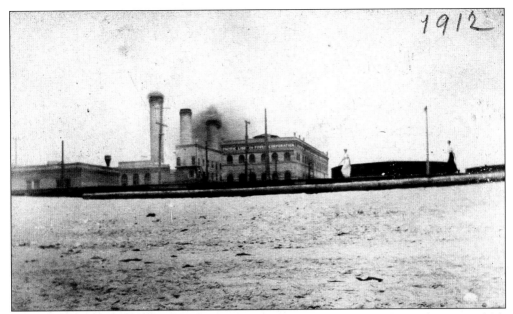

1912

EMERGENCY ONLY. By 1920, a hydroelectric power plant was built in the High Sierra, which lightened the burden on the Redondo Beach plant. By 1928, it was used for emergencies only, such as the 1933 Long Beach earthquake. With Edison's Long Beach generating station out of commission, the Redondo steam plant supplied most of the power that helped the area recover.

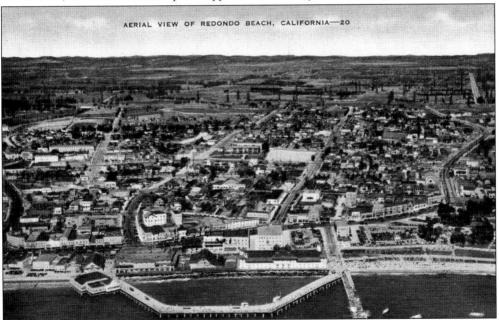

AERIAL VIEW OF REDONDO BEACH, CALIFORNIA—20

OIL WELLS. Early Redondo Beach was ringed with oil wells as companies began drilling and pumping their way through Southern California. The Redondo Oil Corporation was formed in 1920, when businessmen leased land at the corner of Anita Street and Camino Real (later Pacific Coast Highway) from the city. Shortly after drilling began, a rumor was started that oil had been hit at 2,500 feet. But an investigation showed that the well was a sham, and the perpetrators were sent to jail, thereby ending the Redondo Oil Corporation.

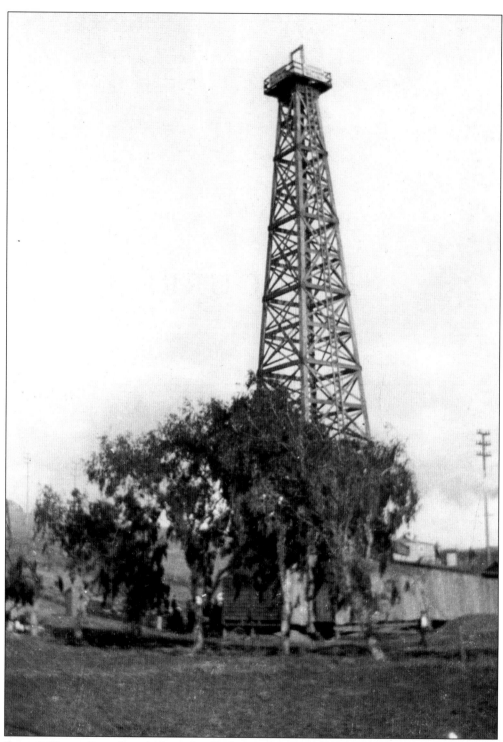

STEADY FLOW. Even though the early oil adventure was a bit slippery, wells such as this one did produce abundantly. The Del Amo No. 1 was brought in on June 8, 1922 with a steady flow of 900 barrels a day, giving birth to Redondo Beach's legitimate oil industry.

Nine

POTPOURRI

Woven throughout Redondo Beach's history are those who have endured, who have risked their lives and fortunes to stay and make the place their own. They survived storms, recessions, and even Prohibition to become the legends, the entrepreneurs, the famous and infamous, and the wonderfully ordinary whose contributions are countless. To all who helped make Redondo Beach what it has become, the Historical Commission of Redondo Beach appreciates your legacy.

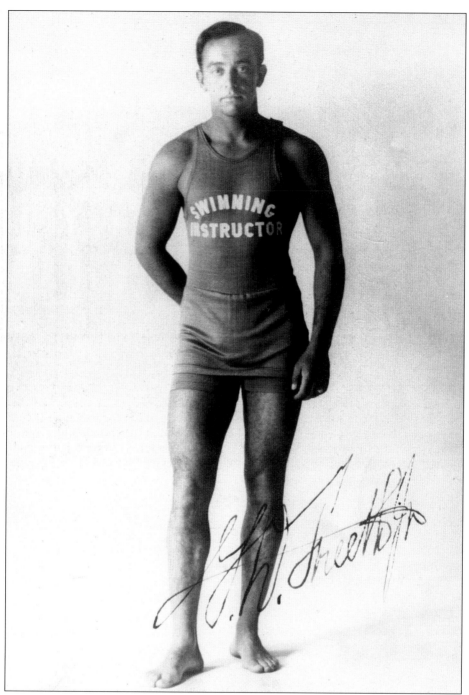

GEORGE FREETH. Developer Henry Huntington brought Hawaiian surfer George Freeth to Redondo Beach in 1907. Huntington hoped that Freeth's stunts on his 10-foot, 200-pound wooden surfboard would attract a crowd of potential property buyers. But even experienced swimmers were drowning, and some people were reluctant to buy near the beach. Freeth organized fellow surfers into the Volunteer Life-Saving Corps and became Los Angeles County's first lifeguard. He was honored with the Congressional Gold Medal for heroism for his lifesaving work.

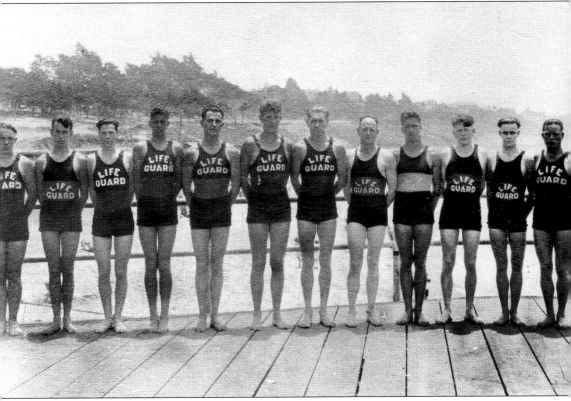

LIFEGUARDS. This group worked as lifeguards at the three pools in the Plunge in 1927. Even though lifeguard founder George Freeth died in 1919, decades later people still talked about the dazzling stunts he performed. One of the crowd-pleasers featured Freeth jumping off the Redondo Beach pier, landing on a horse, and riding up and down the surf.

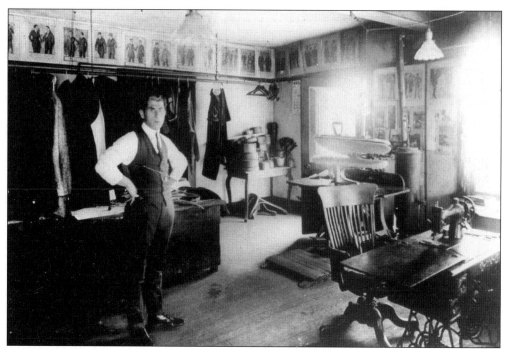

PARISIAN CLEANERS, 1912. One of the growing community's first businesses was the Parisian Cleaners, which used dry-cleaning techniques straight from Europe. Note the sewing machine, which enabled the cleaners to do mending and tailoring.

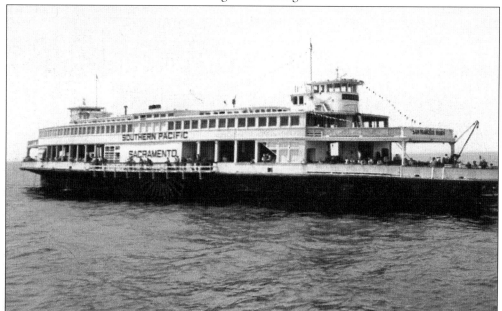

THE *SACRAMENTO*. As the fishing industry grew and tourists wanted their crack at the sport, barges and boats were devoted to day-long excursions. Sponsored by the Southern Pacific Railroad, the *Sacramento* was anchored two and a half miles off Redondo Beach to accommodate some 350 people in relative comfort. The *Sacramento* originally was in daily service as a ferryboat on San Francisco Bay.

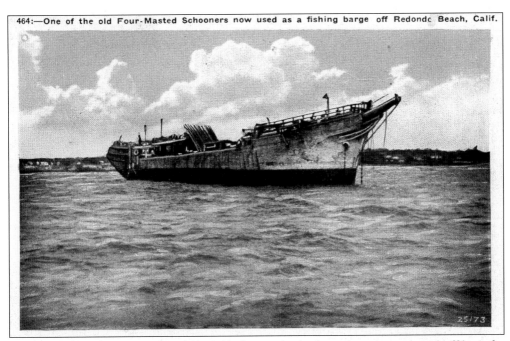

464:—One of the old Four-Masted Schooners now used as a fishing barge off Redondo Beach, Calif.

ANOTHER BARGE. At one time, four old, four-masted schooners were anchored offshore for use as fishing barges.

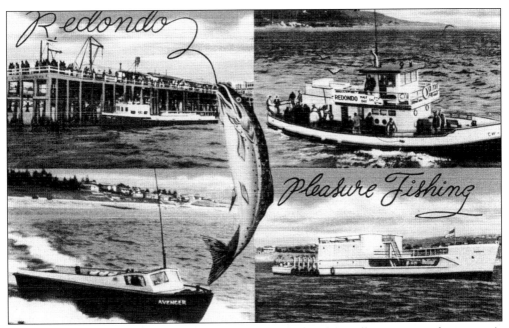

PLEASURE FISHING. Promoters promised three big barges with galley service and water taxis that left every hour, on the hour. Barges were open all night from June to September and tackle stores along the Monstad pier opened at 6:00 a.m. Boat rides were 25¢ for a 20-minute bay cruise or $3 for an all-day fishing barge

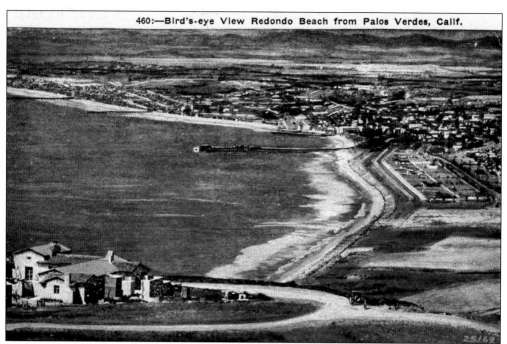

1930 VIEW. This view from the Palos Verdes Peninsula shows Clifton by the Sea in the foreground with development fanning out from the beach. The card was written in July 1931 and comments on "just how wonderful it is here."

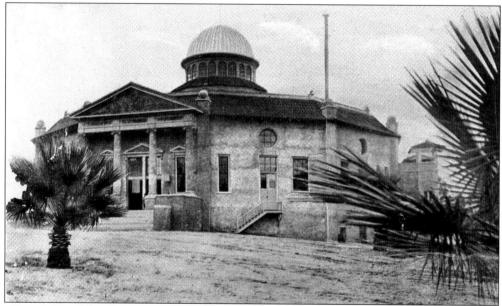

CHAUTAUQUA. Built in 1890, The Chautauqua was part of the nationwide Chautauqua Society and stood at the corner of what later became Pacific Coast Highway and Diamond Street. It was an imposing structure with 11 sides and a glass dome. By 1910, more than 10,000 such buildings could be found nationwide as meeting halls for speakers and performers. William Jennings Bryant addressed the Redondo Beach audience. The building was purchased in 1906 and was the high school until 1915.

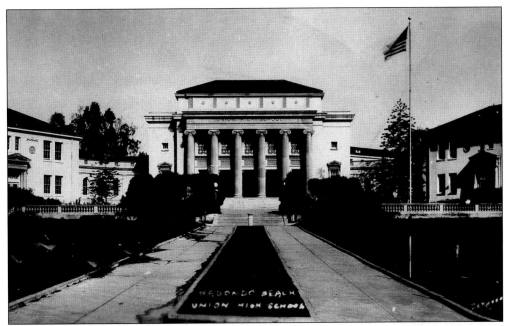

UNION HIGH SCHOOL. As the town grew, so did its educational facilities. Union High School opened its doors in 1905 and teachers conducted classes in upstairs rooms at the Masonic Hall until 1907 when the school moved to the former Chautauqua site.

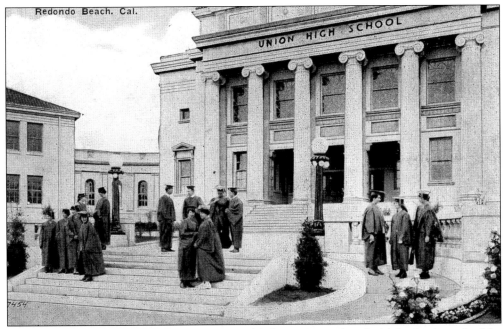

GRADUATION. When the Chautauqua was remodeled to accommodate the high school, much of the original architecture was enhanced. The columns gave the school a "temple of learning" appearance. They were later destroyed after the 1933 Long Beach earthquake weakened the structure.

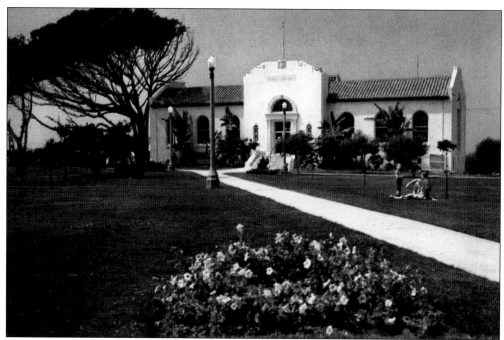

1930 LIBRARY. Built in 1930, this structure in Veteran's Park is listed on the National Register of Historic Places, along with the Woman's Club at 400 South Broadway and the Sweetser Residence at 417 Beryl Street. The Redondo Beach Original Townsite Historic District was listed in the National Register in 1988. It is bounded by Diamond Street, Carnelian Street, Guadalupe Avenue, and Francisco Avenue. At left is a 100-year-old Moreton Bay fig tree.

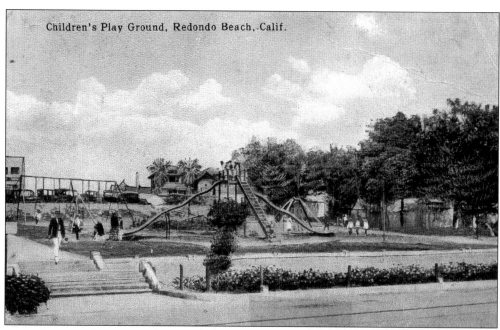

Children's Play Ground, Redondo Beach, Calif.

CHILDREN'S PLAYGROUND. Just north of Tent City, the Children's Playground offered slides and swings to keep youngsters occupied.

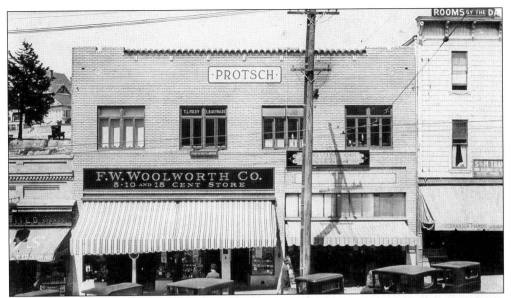

F. W. WOOLWORTH. In the 1920s, Redondo Beach shoppers enjoyed the treasures of the 5¢, 10¢, and 15¢ store located in the 100 block south on Pacific Avenue in the Protsch Building.

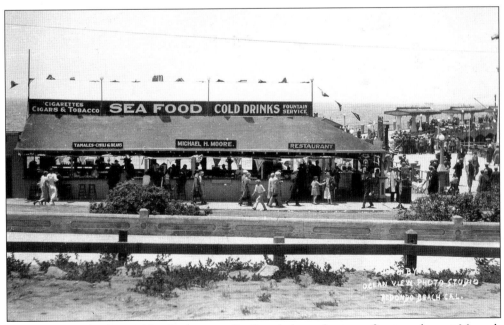

SEAFOOD. By the late 1920s, food was easily found along the oceanfront, such as at Moore's Restaurant, which pushed tobacco, cold drinks, tamales, and chili.

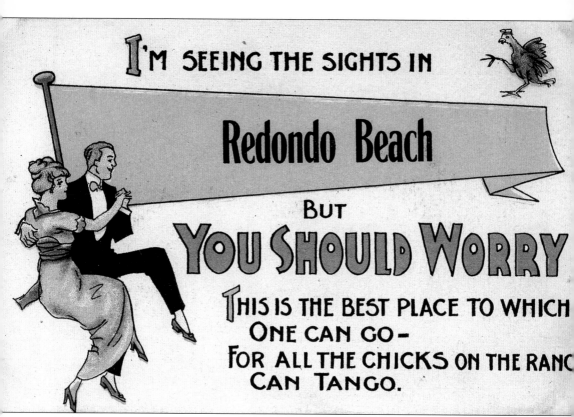

I'M SEEING THE SIGHTS IN

Redondo Beach

BUT YOU SHOULD WORRY

THIS IS THE BEST PLACE TO WHICH
ONE CAN GO –
FOR ALL THE CHICKS ON THE RANC
CAN TANGO.

WARM HERE. "It's warm here," says this postcard that was sent to a friend in Los Angeles in September 1912. The postcard company probably inserted different city names for each community up and down the coast.

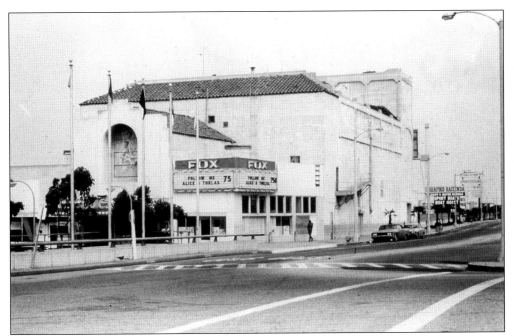

FOX THEATER. Built in 1928, the Fox Theater was demolished in 1973 as part of Redondo Beach's massive redevelopment. An enemy of history, the wrecking ball did not swing unopposed. Many of the city's longtime residents sought to keep its grand curtains, decorative aisle markers, and oceanfront location. Tickets were 25¢ in the early days.

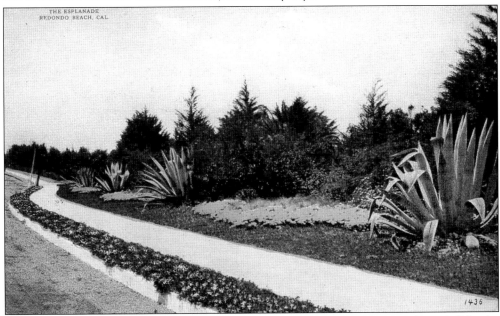

LOVELY LANDSCAPE. Redondo Beach always presented a floral face to Southern California. This area long the Esplanade was cultivated in splashes of yellow amongst the greenery in the 1930s. Carnation gardens, in the general vicinity of Ruby and Sapphire Streets east of Catalina Avenue, offered 12 acres of fragrant flowers that were almost always in bloom, thereby inspiring people to call Redondo Beach the Carnation City.

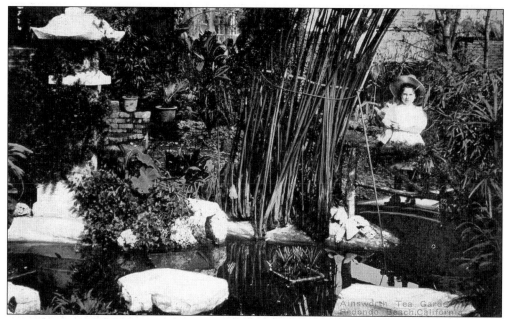

TEA GARDEN. This 1920 view of a tea garden in Redondo Beach inspired a postcard to a friend in Pasadena commenting on the fact that the garden was on the Balloon Route of the Los Angeles Pacific Railway.

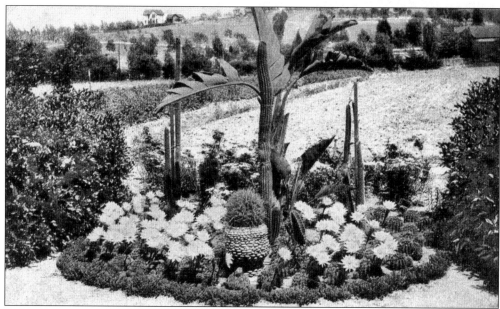

CACTUS GARDEN. Much of early Redondo Beach was landscaped to take advantage of the warm ocean breezes and mild weather. The fact that early Southern California was an extension of the desert made it particularly easy to enjoy cactus plants as centerpieces.

110

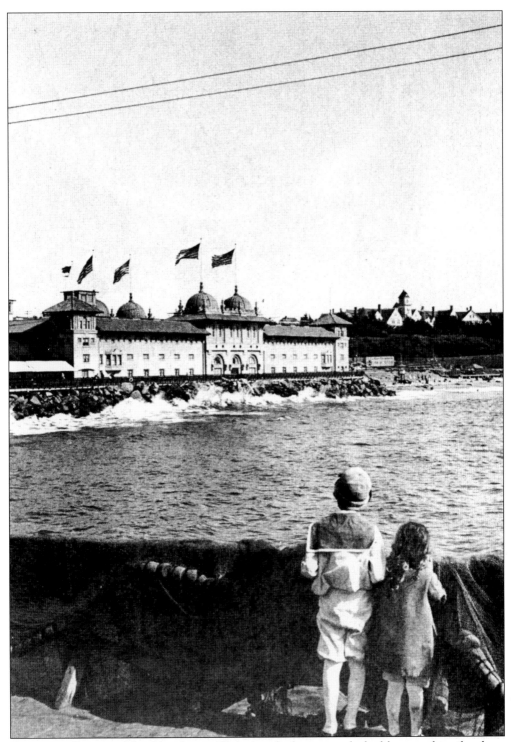

BIRTHDAY OUTING. A local brother and little sister look across at the bathhouse, where they have been promised a birthday swim after a picnic on the pier. Hotel Redondo is at the upper right.

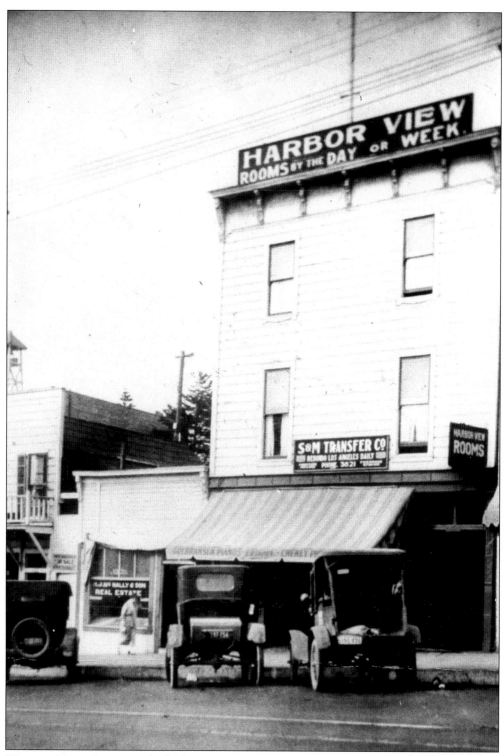

HARBOR VIEW. Rooms with a harbor view were available by the day or week all along Redondo Beach's downtown area. There was plenty of room to park with no parking meters.

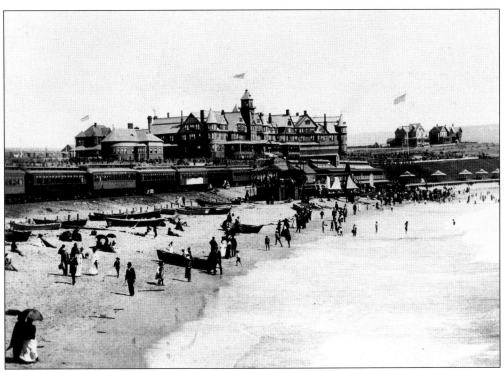

MORE ROOMS WITH VIEWS. This 1903 postcard shows the train between the beach and the Hotel Redondo.

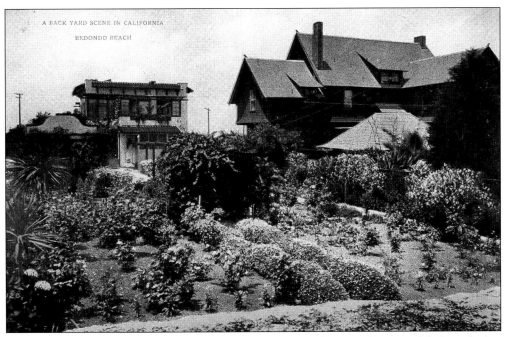

A BACK YARD SCENE IN CALIFORNIA

REDONDO BEACH

LUSH LAWNS. Most homeowners enjoyed California's warm climate and practiced their gardening skills with aplomb.

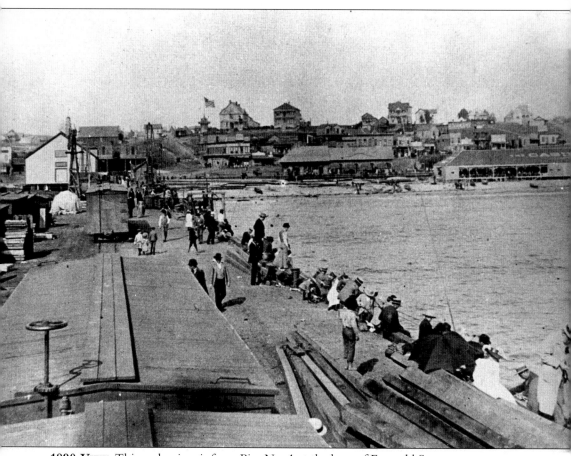

1890 VIEW. This early view is from Pier No. 1 at the base of Emerald Street.

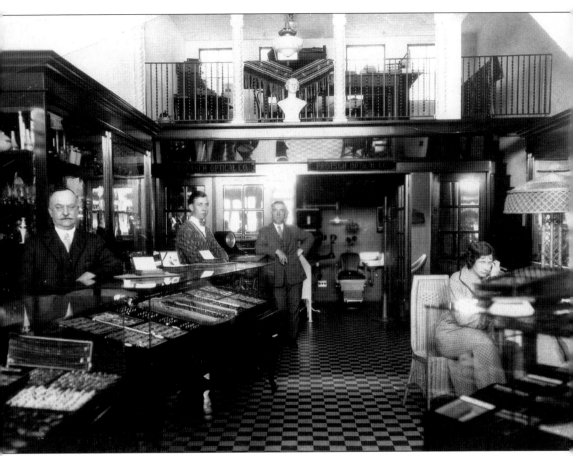

GENERAL STORE. Everything from jewelry and candy to the cliché kitchen sink was available in the general store. Stores were closed on Sunday. Note the woman on the telephone in the lower right. Redondo Beach had two telephone companies, but they were not interconnected until the early 1930s.

BOARDINGHOUSE. Typical of the 1915 era, boardinghouses offered rooms by the month with meals. Two rooming houses, the Aberdeen on Benita and the Colorado in the Myers Block, had running water and an electric light in each room. The Colorado rented for $2 a night. All rooms had ocean views.

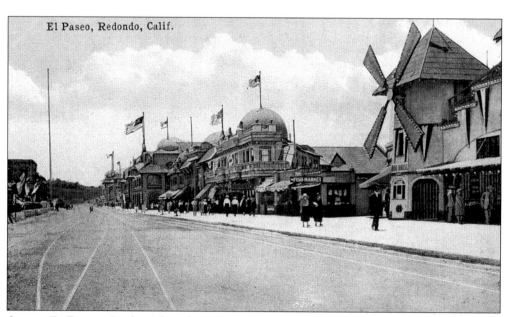

ALONG EL PASEO. On the right is the entrance to the Rapids, one of the many rides; the Spanish Cafe is also on the right. There is a hint of Tudor influence in the half-timbered structure.

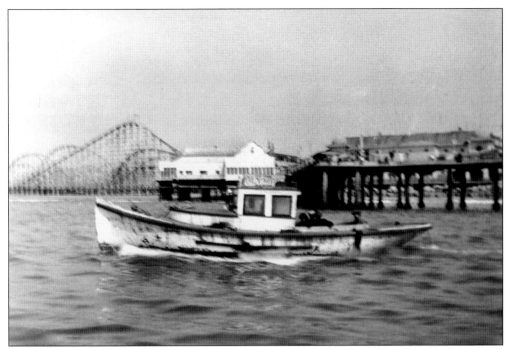

LOOMING HIGH. Visible from throughout the area is the Lightning Racer, the looping and dipping wooden roller coaster that lured the adventurous to the beach. In the center is the Hippodrome with its gala carousel. Families traveled by horse and buggy to ride the beautifully carved and decorated horses of Looff's merry-go-round. The foreground features fishermen out for the day.

NO PARKING PROBLEM. This house on the Esplanade has enough room at the side for the owner to park his new Ford. Note the balloon tires. During this time, lots sold for $90 with $4 down and $4 a week, with no interest or taxes.

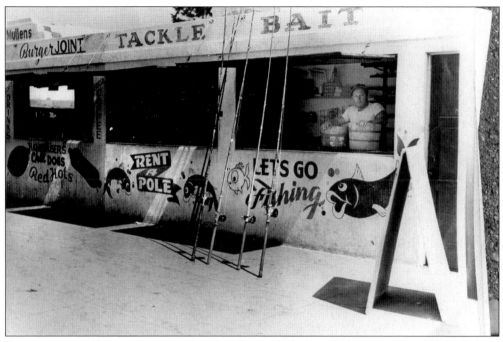

REFRESHMENT STAND. One-stop shopping for tackle, bait, and a burger was available all along the beach.

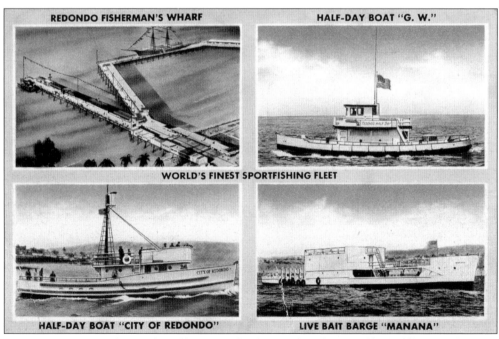

WORLD'S FINEST. This card proclaims Redondo Beach as having the World's Finest Sports Fishing Fleet. With choices of half- or full-day operations, tourists could hope for record catches. Live bait was also offered.

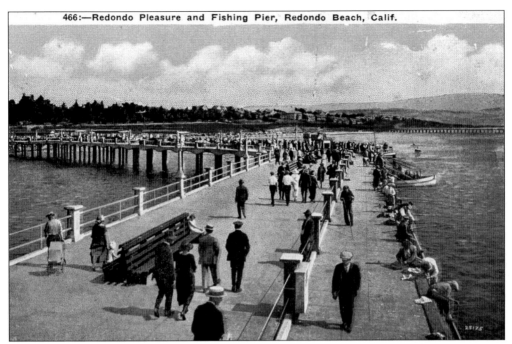

466:—Redondo Pleasure and Fishing Pier, Redondo Beach, Calif.

DAY ON PIER. This late-1920s scene shows people enjoying a stroll and fishing off the pier with small crafts tied alongside. Clifton by the Sea is in the background, with the Palos Verdes Peninsula at upper right.

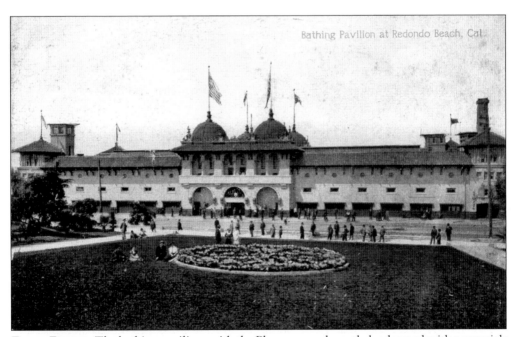

Bathing Pavilion at Redondo Beach, Cal.

FLAGS FLYING. The bathing pavilion, with the Plunge, was elegantly landscaped with perennials that were always blooming. Perhaps this scene was part of the gala grand opening, which newspapers of the day said was "fit for a king's coronation."

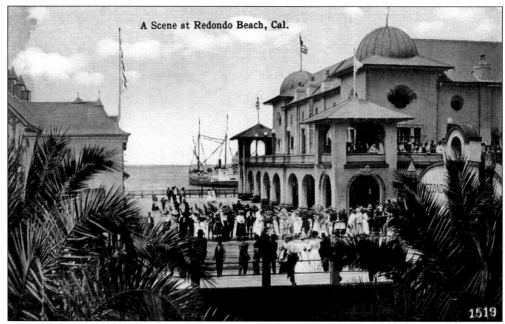

A Scene at Redondo Beach, Cal.

1519

GOING ON A PICNIC. The writer of this January 1910 card says she hopes her family can "go on a picnic in this beautiful weather." The scene is between the pavilion and the bathhouse, with the Santa Fe Station on the right.

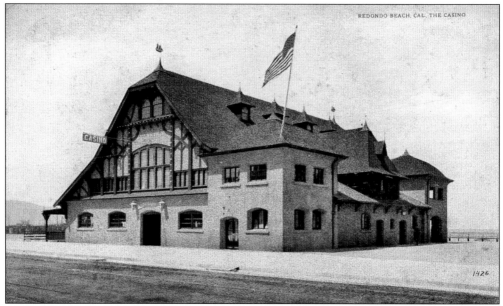

REDONDO BEACH, CAL. THE CASINO

CASINO

1426

GAMBLING AND GANGSTERS. Although the Great Depression choked the nation in the late 1920s, Redondo Beach's gaming parlors continued to attract visitors, especially the lucrative professional gambling trade. Apart from spending their dollars in places such as the Casino, professional gamblers bought goods and services from the local merchants. Unfortunately, the stereotype of the 1930s gangster also arrived, bringing the mixture of wanted revenue and unwanted crime. By 1937, the newly formed junior chamber of commerce began to clean up the El Paseo district, thereby forever changing the character of the city.

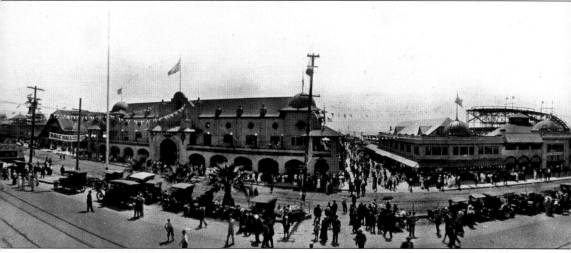

BIRD'S-EYE VIEW. This 1923 view of the Redondo Beach amusement area is from the base of Emerald Street. On the left, the red car has arrived. The large building in the center housed the Mandarin Ballroom that could accommodate 500 dancing couples. At right is the top of the Lightning Racer that had restaurants nearby and a band shell for concerts.

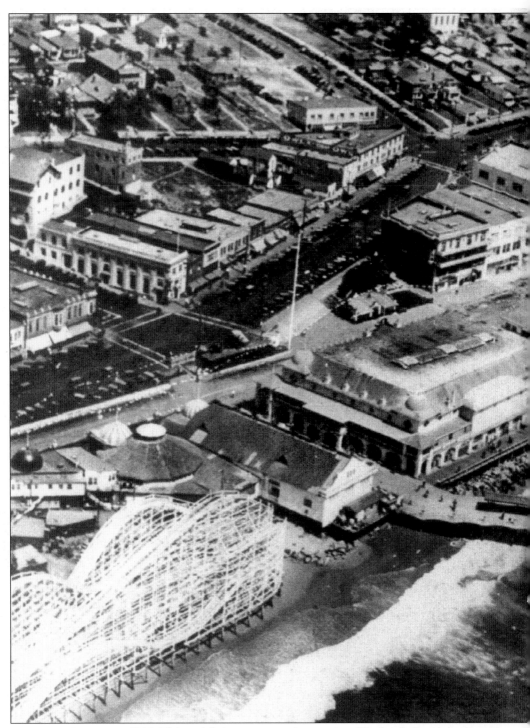

REDONDO BEACH, C. 1920. This aerial view captures the essence of Redondo Beach in the early 1920s. The annual migration of winter tourists that fueled the original growth had stabilized into a community with a city government, city services, and an identity that incorporated much more than just a beach resort. The sprawling Hotel Redondo (above, far right) had seen its glory

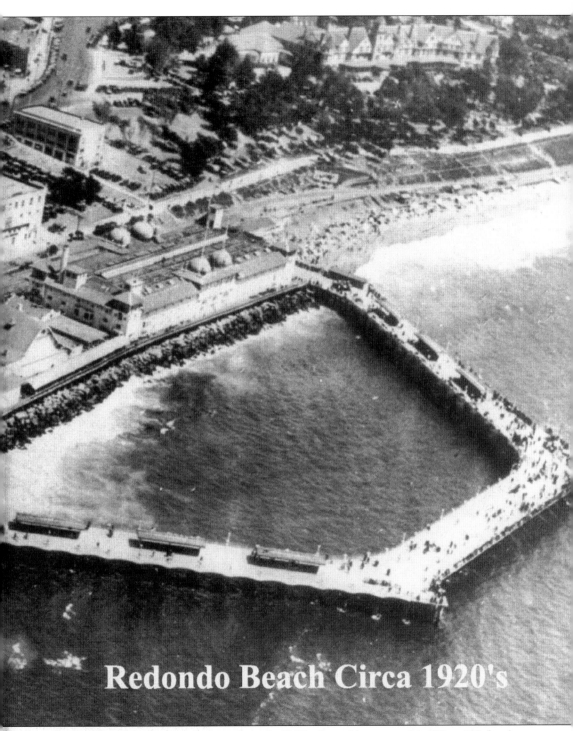

Redondo Beach Circa 1920's

years by the time this photograph was taken. In 1922, the residents voted 1,600 to 250 for the purchase of the hotel as a civic center, but it never materialized. The Lightning Racer, at lower left, was demolished in 1924.

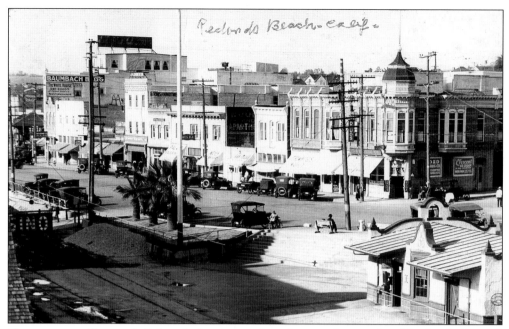

DOWNTOWN. Shops of all descriptions catered to the growing needs of Redondo Beach's residents. People even came from surrounding cities to enjoy the downtown shopping that afforded easy parking.

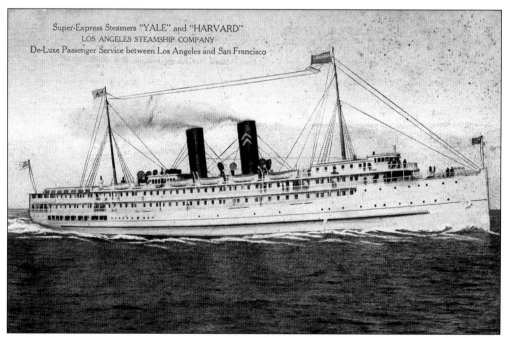

SUPER EXPRESS. Super-express steamers, the *Yale* and the *Harvard*, sped passengers between Los Angeles and San Francisco, offering what it called "deluxe passenger service."

REDONDO BEACH
CITY ADMINISTRATION
2005

Mayor	Mike Gin
Council District 1	Steve Aspel
Council District 2	Chris Cagle
Council District 3	Don Szerlip
Council District 4	Steven Diels
Council District 5	John Parsons
City Attorney	Mike Webb
City Clerk	Sandy Forrest
City Treasurer	Ernie O'Dell
City Manager	William Workman

Redondo Beach Timeline

1541: Spanish explorers reach Redondo Beach after landing in Baja California six years earlier.

1784: Spanish Land Grant of 75,000 acres including Redondo Beach goes to Juan Jose Dominguez.

1850: Captains J. C. Ainsworth and W. R. Thompson begin their steamship line on the Columbia River in Oregon.

1890: Redondo Railroad runs 17 miles of track to Los Angeles, and Hotel Redondo opens.

1892: County supervisors certify vote of 177 to 10 in favor of incorporating Redondo Beach as a sixth-class city.

1893: Christ Episcopal Church founded.

1894: S. D. Barkley opens the Redondo Breeze newspaper.

1899: Congress approves building a breakwater in San Pedro, thereby moving the port to Los Angeles.

1903: Pacific Crest Cemetery opens on Inglewood Avenue.

1907: Henry Huntington brings George Freeth from Hawaii to Redondo Beach.

1909: The Plunge is built.

1911: Boston Red Sox baseball team comes to town.

1914: Winter storms rip beach.

1915: El Ja Arms Hotel built. Storms tear into beach property.

1917: A young Charles Lindberg attends Redondo High School while the family lives briefly at 408 South Catalina.

1925: Hotel Redondo is demolished and sold for scrap.

BIBLIOGRAPHY

Basten, Fred E. *Santa Monica Bay, the First 100 Years.* Los Angeles: Douglas West Publishers, 1974.

Bell, Horace. *On the Old West Coast: Lanier Bartlett.* New York: 1930.

Daily Breeze: 90th Anniversary Commemorative Edition. Torrance, California: 1982.

Daily Breeze: A Centennial Tribute. Torrance, California: 1992.

Gillingham, Robert Cameron. *The Rancho San Pedro.* Los Angeles: Dominguez Estate Company, 1961; Revised ed. Museum Reproductions: Judson A. Grenier, 1983.

Grenier, Judson, A. *A California Legacy.* Los Angeles: 1987.

Johnson, Ken. *Fun, Frustration and Fulfillment.* Redondo Beach: 1965.

National Archives Center, Bureau of Customs. Records of Wreck Reports. Los Angeles.

McCandless, Michael. *Well, at Least We Tried.* Redondo Beach: self-published, 1980.

Newmark, Harris. *Sixty Years in Southern California: 1853–1913.* New York: The Knickerbocker Press, 1916.

Redondo Breeze: Souvenir Edition. Redondo Beach: 1905.

Richardson, Curt. *90th Anniversary.* Oswego, NY: Caruso Press, 1982.

Shanahan, Dennis. *Old Redondo: A Pictorial History of Redondo Beach.* Designed by William Fridrich. Redondo Beach: Legends Press, 1982.

Verge, Arthur. Images of America: *Los Angeles County Lifeguards.* Charleston, SC: Arcadia Publishing, 2005.

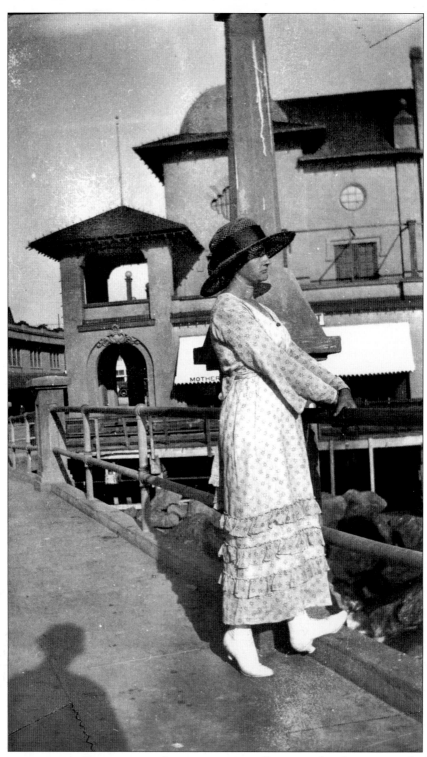

REMEMBERING AND REFLECTING. A young woman reflects on what she was seen during her sojourn to Redondo Beach, *c.* 1915.